IMAGES
of America
WAYNE TOWNSHIP

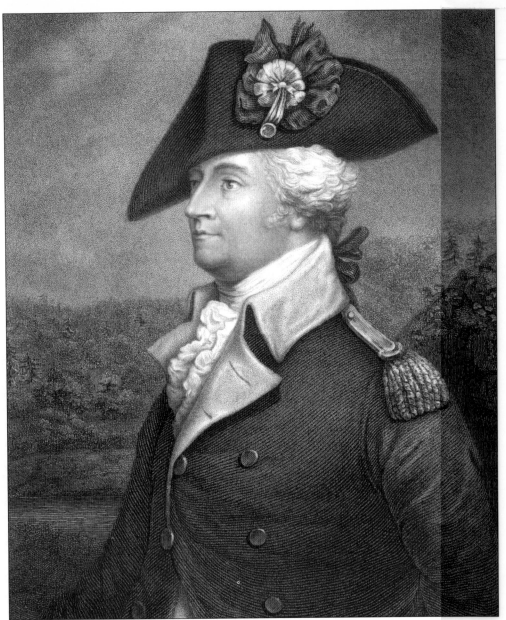

Wayne Township was named in honor of Brig. Gen. Anthony Wayne. Born on January 1, 1745, Wayne began his military career supporting Benedict Arnold's forces in Canada. He was given command of Fort Ticonderoga in the winter of 1776–1777, distinguished himself in the battle of Brandywine Creek against the Hessians, and led his troops in the Battle of Monmouth, where he is reputed to have held his ground in an apple orchard, as his Pennsylvanians "picked off" the enemy. In 1779, Wayne was given command of an elite force, which successfully attacked the fort at Stony Point on the Hudson River. Wayne attended General Washington at his Dey Mansion headquarters in Wayne during 1780, where other officers criticized him for his lack of military etiquette and the failed attempt to lure the British to the west shore of the Hudson by the attack on the Bull's Ferry Blockhouse. His impulsive and sometimes rash behavior in battle earned him the nickname "Mad Anthony."

IMAGES
of America

WAYNE TOWNSHIP

Cathy Tobin

ARCADIA

First printed in 2001.

Published by Arcadia Publishing,
an imprint of Tempus Publishing, Inc.
2A Cumberland Street
Charleston, SC 29401

Printed in Great Britain.

Library of Congress Catalog Card Number: 2001093531

For all general information contact Arcadia Publishing at:
Telephone 843-853-2070
Fax 843-853-0044
E-Mail sales@arcadiapublishing.com

For customer service and orders:
Toll-Free 1-888-313-2665

Visit us on the internet at http://www.arcadiapublishing.com

CONTENTS

ACKNOWLEDGMENTS

As a 20-year resident of Wayne Township, I found the undertaking of this historical publication to be a challenge I thoroughly enjoyed. Any research effort includes hours of unfruitful searching and that exhilarating moment of satisfaction when the great questions are answered by the elusive document—the piece of correspondence, deed, indenture, map, drawing, or photograph finally located. I am greatly indebted to many for their help in finding so many answers and creating new questions for future researchers.

The members of the Wayne Township Historical Commission have created an archive of historical information, which formed the basis for many aspects of the research for this book. Specifically, I wish to extend thanks to commission chair Dr. Robert Brubaker for his willingness to answer any question and to commission member and archaeologist Edward Lenik for his always scholarly and professional inspiration and providing the use of photographs. Commission member Marcia Sills spent many hours identifying photographs in the archives, some of which are used in this publication.

The assembly of more than 200 historical photographs clearly requires a group effort, and that was exactly what occurred. Assistance in locating the photographs was cheerfully given over many months by Bruce Balistrieri, curator of the Paterson Museum. Thanks also go to Andrew Shick, director of the Passaic County Historical Society, and assistant director, Gloria Stroedecke, for their help in providing 20th-century photographs from their collections. Marge Hannan of the Pompton Lakes Historical Commission provided information about Albert Payson Terhune and Cecile B. DeMille. Nicole Wells and Eleanor Gillers at the New-York Historical Society arranged for permission to use an image of Arent Schuyler and quickly supplied a copy to help me meet my deadline. I would also like to thank Michael Bedford for his cooperation and assistance.

The staff at Arcadia Publishing in Portsmouth, New Hampshire, was professional, knowledgeable, and supportive. Special thanks go to Peter Turco, who helped me get started, and Susan Jaggard, who brought it all to a successful conclusion.

Researching and writing a book takes away from family time. I wish to thank my children, Clare and Hilary, for permitting me to share with others the history of the community in which they are growing up. Warmest thanks to my husband, Jeff, for spending the last 27 years looking at architecture with me. You have taught me so much. Lastly, I wish to thank my parents, Bob and Verna Harding, for their stories and the laughter and for instilling me with an understanding of family and community, of ties and responsibility, and of love in that gentle way only they could.

—Cathy Tobin
August 2001

INTRODUCTION

Residents of Wayne Township, at the time of its incorporation in 1847, inhabited a very different environment than the suburban residential community of the 21st century. The rich, cultivated fields of grains and potatoes and the forested hillsides and valley pasturelands dotted with grazing dairy cows characterized the agrarian landscape firmly established in the 19th century. Picturesque family farmsteads with barns, smokehouses, icehouses, and root cellars were serviced by the gristmills, sawmills, and blacksmiths. Horse-drawn wagons carried produce to market along unpaved country roads. Buggy rides to church on Sunday were special occasions.

Today, 26 square miles of a diverse assemblage of residential neighborhoods, lake communities, office developments, light industrial buildings, and retail shopping centers are interwoven by four major highways. Progress—the arrival of the bulldozer, the crane, the motorcar, and electricity—forever changed the physical landscape of Wayne Township.

Yet Wayne's residents have a special appreciation and respect for history, family, and responsibility to past and future generations. Despite pressures of development, more than 30 historic structures and landscapes have been preserved through both public and private investment. Wayne Township maintains and operates three 18th-century Dutch Colonial farmhouses as historic house museums and is the custodian of more than 2,000 acres of parklands and protected forests.

Traversed by Native Americans for thousands of years, sold in 1695 to Dutch businessmen, and inhabited today by a multicultural population, Wayne Township has grown and evolved with the influence of each group. Three hundred years after the Lenapes lived in the area, words derived from their language—Preakness, Packanack, Pompton, Singack, and Minnisink—are used to describe neighborhoods and natural features. Traveling the highways and turnpikes, automobiles follow ancient Native American trails. Names of original Dutch settlers lend themselves to streets, communities, and public buildings—Schuyler, Ryerson, Mandeville, Hinchman, Berdan, Colfax, MacDonald, and Dey. Dutch churches continue to serve the community.

The activities of Gen. George Washington and the Continental Army in the fight for America's freedom in 1780 were centered in Wayne at the Dey Mansion. The Preakness valley was considered a strategic location for the army due to the availability of food for the soldiers, protection for General Washington, and proximity to iron forges to supply shot and cannon balls and to New York to observe the movements of General Cornwallis and the British forces. Strategic plans made at the Dey Mansion may well have changed the course of the war and led to the surrender of the British at Yorktown. The military figures who served Washington have left a legacy to Wayne Township as well and are remembered prominently in our history.

The physical transformation of Wayne from an agrarian landscape to a suburban residential community occurred most rapidly in the 20th century. The economy of early Wayne in the 18th and 19th centuries revolved around the farm and its associated industries. The population

was thinly spread across the landscape, with a few small centers of commerce, including the Hamburg Turnpike and Mead's Basin, which later became Mountain View. An 1850 account of the area describes a small community of about 12 buildings.

The Morris Canal Pompton feeder, begun in 1836, aided the economy of the Mead's Basin community. Canal boats passing through with their cargo created a need for a blacksmith, hotel, restaurant, and general store. The construction of railroads in the late 19th century made the movement of cargo and produce by canal boat obsolete.

The industries spawned in the late 19th century were aided by the railroad service into Wayne. Two competing rail lines, the Erie and the Lackawanna, both operated stations in Mountain View. Six brickyards and a powder works company utilized the rail lines. Workers and products were transported to and from these industrial sites.

The arrival of the motorcar allowed residents to travel farther from home for the necessities and newly available comforts of life. The ease of travel and short commutation from large cities, primarily Paterson and later New York, made Wayne an ideal location for a permanent residence. Wayne provided fresh air, a country environment, proximity to lake and river recreation, shopping, houses of worship, and limited industrial growth. Development pressures and rising land values forced many farmers to sell acreage for residential construction.

The business centers of the settlements began to lose customers. The general store, grocery, tearooms, cafes, blacksmith shops, gristmills, and sawmills—the necessary support businesses and industries of a farming community—rapidly disappeared in the 20th century. They were replaced with the supermarket, department store, gas station, hardware store, and roadside food stand or restaurant. The larger highway stores attracted customers away from the small mom-and-pop stores with a limited selection of products. The new gas stations were convenient refueling stops for the motorcars as residents ventured farther and farther from home for a Sunday afternoon drive or vacation.

One by one, country lanes were paved. The noise of the automobile engine replaced the sounds of the horse and buggy. The two major turnpikes in Wayne—the Paterson-Hamburg Turnpike (once traversed by busy stagecoach and commercial wagon traffic from Passaic and Paterson to Pompton and Hamburg) and the Newark-Pompton Turnpike (extending from Newark, north through Mead's Basin to Pompton)—bowed to the new automobile traffic. Bus service replaced the stagecoach lines, and trucks moved the farm produce that had taken five hours by horse and wagon to reach the markets in Paterson in the 19th century. As the thoroughfares became more crowded, the roads were widened and straightened. Superhighway Route 23 divided the quiet Mountain View community in 1936. Routes 46 and 80 brought commercial development.

The availability of electricity extended the daylight, and it was no longer necessary to awaken and sleep with the sun. The electrified streetlights made traveling the highways at night safer, and food service establishments were able to remain open long into the evening hours. These included roadside stands, restaurants, cafes, clubs, and taverns, where anything from a hot dog to a seven-course dinner followed by dancing were available. These gathering places further eroded the social life provided by the community clubs and front porches along main streets. The summer evening stroll was enjoyed by fewer residents, as many now rode in their cars to the highway ice-cream stand.

Advertising and signage sprang up along highways and many local roads. Large shopping malls, which were enclosed later in the century, provided shopping in a controlled environment, making a large number of products available, all under one roof.

Residential subdivision development increased the need for community services. New schools, increased police and fire protection, and first-aid services were required, as was access to a community drinking water system.

This publication explores these monumental physical and social changes and features more than 200 rare images that reveal the visual richness and historical charter of Wayne Township in the last century.

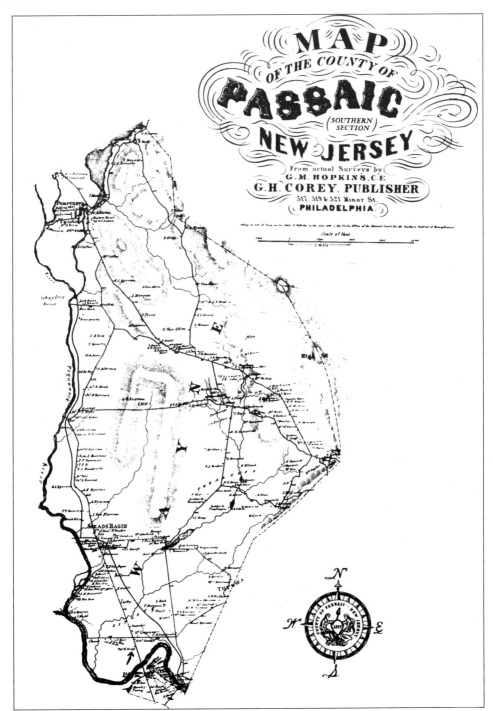

This 1861 Passaic County map, which records the development of Wayne Township, illustrates the sparse settlement of the farming community. Residences, barns, and other buildings are clustered along the major transportation routes: Hamburg Turnpike, Newark-Pompton Turnpike, Black Oak Ridge Road, Ratzer Road, Valley Road, the Pequannock and Passaic Rivers, and the Singack Brook.

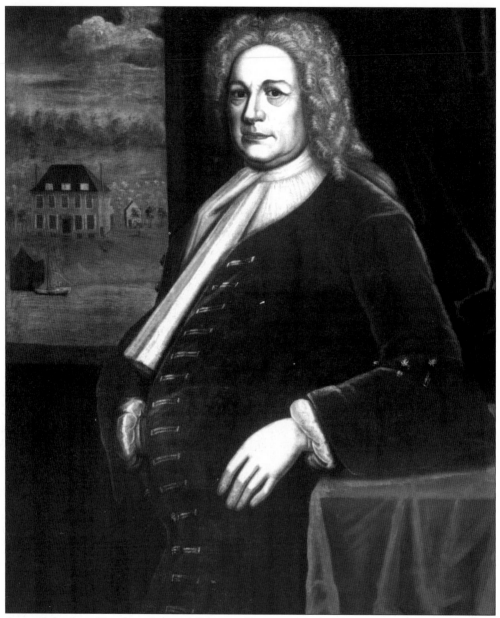

Arent Schuyler—Dutch trader, merchant, and scout—traveled from the fort at Albany, New York, to northwestern New Jersey many times in the 1680s. He wrote of crystal-clear brooks and wide streams. He noted pastureland, Native American orchards, and cultivated fields perfect for raising corn, tobacco, beans, and squash. From his examination of the stone tools used by the Native Americans, he concluded that mineral deposits might exist in the area. Schuyler was describing "a wondrously beautiful valley" that today is called Wayne Township. His enthusiasm for the area attracted the attention of Dutch businessmen, who joined him in a venture to purchase the land. Schuyler built the first permanent residence along the banks of the Pompton River c. 1695. Known today as the Schuyler-Colfax House, it has been the home of eight generations of Schuyler descendants. This oil-on-canvas painting is attributed to John Watson. (Collection of the New-York Historical Society, ac. No. 1979.75, Neg. No. 57109.)

One

DUTCH SETTLEMENT OF THE VALLEY

Traversed by Native Americans for thousands of years, Wayne Township was settled by Dutch businessmen and farmers following the purchase of the land from Native Americans in 1695. Arent Schuyler negotiated the transaction for the value of 250 English pounds in goods, merchandise, and wampum. Schuyler's partners in the venture negotiated the sale with the East Jersey proprietors, the original Quaker purchasers of the province of East Jersey, who also claimed ownership of the land. Consisting of 5,500 acres of the river valley in the western and southern portions of Wayne Township, the property was divided into the Pompton Patent and the Upper and Lower Pacqanac Patents. Initially part of the East Jersey county of Essex, the lands became part of Bergen County after 1710.

Schuyler's eight business partners included Maj. Anthony Brockholst. One of his descendants married the wife of William Livingston, governor of New Jersey during the Revolutionary War. Another became the wife of John Jay, the first chief justice of the U.S. Supreme Court.

New York merchants Col. Nicholas Bayard and his son became investors. Bayard served as provincial secretary, commander of the provincial militia, and mayor of the city of New York. Samuel Bayard served as treasurer of the city of New York. Other members of the joint venture included weaver John Mead and farmers Samuel Berry, George Ryerson, Hendrick Mandeville, and his son David Mandeville.

The first Dutch residents were Schuyler and Brockholst, who built homes in the Pompton area sometime before 1698. Samuel Berry built a residence just north of today's Mountain View, which a deed labels "Sleckbergh." John Mead's family settled the Mead's Basin area, now known as Mountain View. George Ryerson built his farmhouse west of the Newark-Pompton Turnpike and north of Mead's Basin. The Mandeville homestead was constructed west of current Route 23, adjacent to the Mead settlement. Both father and son were recorded as residents by 1701.

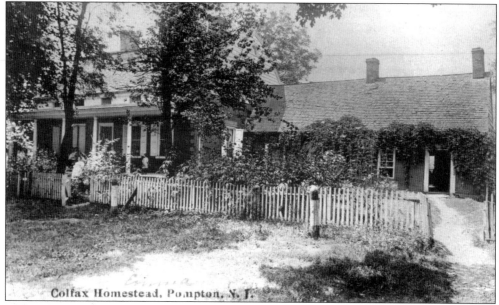

Colfax Homestead, Pompton, N. J.

The Schuyler-Colfax House was home to the Schuyler-Colfax family for 300 years. Arent Schuyler is believed to have constructed the original one-room farmhouse on the right. Ownership passed to his great granddaughter Hester Schuyler, who married William Colfax, commander of George Washington's Life Guards during the Revolutionary War. Colfax expanded the brick-faced, fieldstone farmhouse with a Dutch Colonial–style addition after their wedding in 1783. This photograph illustrates very little change from the original historic architecture. (Courtesy Wayne Township Historical Commission.)

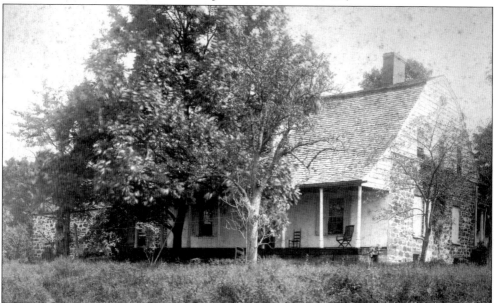

Situated on a strip of land between the Paterson-Hamburg Turnpike and the Pompton River/Morris Canal Pompton feeder, the Schuyler-Colfax House is shown in this 1890 view of the rear porch. The photograph was probably taken from the Colfax Bridge, which crossed the river just south of the house. (Courtesy Wayne Township Historical Commission.)

12

This image of William Colfax as a young officer is a painted miniature, which was given to Hester Schuyler. Hester probably met William at the home of her aunt and uncle, Hester and Theunis Dey, during the encampment of the Continental Army at the Dey Mansion in 1780. Legend says that a young and vivacious Hester won the hearts of many of Washington's officers but returned the love of only one, William Colfax. Later, Colfax became a brigadier general during the War of 1812. (Courtesy Wayne Township Historical Commission.)

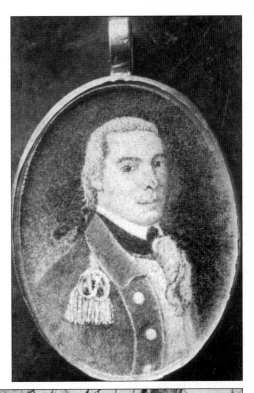

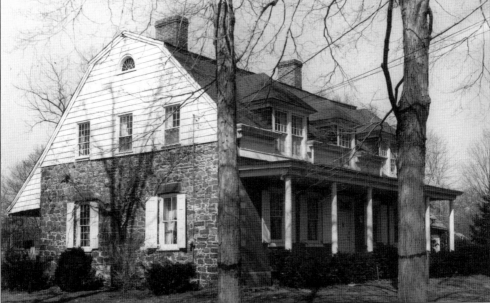

The Schuyler-Colfax House was listed on both the State and National Registers of Historic Places in 1965 due to existing architectural features and the rich history of the family. The 20th-century addition of dormers, which replaced the "belly windows," is one of few architectural changes. The Township of Wayne purchased the house in 1994 from Dr. Jane Colfax and operates it as a historic house museum. (Courtesy Paterson Museum, *Paterson Evening News* Collection.)

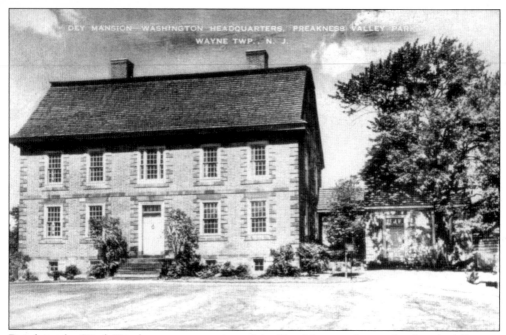

Dutch settler Dirck Dey began construction of the Dey Mansion during the decade following 1740 on his 600-acre estate known as Bloomsbury or Bloomsburg. The eight-room manor house is a fine example of Dutch Colonial architecture with its imposing brick facade and gambrel roof. His son Theunis Dey—who resided there with his wife, Hester Schuyler, and their 10 children—probably completed it. Theunis Dey was colonel of the Bergen County militia and an active political figure, serving as a freeholder, member of the state assembly, and a member of numerous commissions and committees. (Collection of the author.)

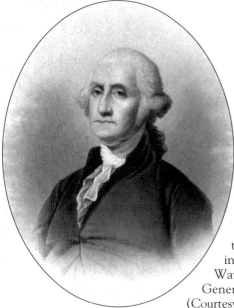

Gen. George Washington established headquarters at the home of Col. Theunis Dey in lower Preakness during July, October, and November 1780. Washington and his military "family," including his aids, Alexander Hamilton, Robert Hanson Harrison, Tench Tilghman, David Humphreys, and James McHenry, occupied the four rooms on the eastern side of the house. Washington was visited by most of the famous military figures of the day during his residence in Preakness. They included the Marquis de Lafayette, Gen. Anthony Wayne, Maj. Gen. Lord Stirling, Benedict Arnold, General Howe, and the Marquis de Chastellux. (Courtesy Wayne Township Historical Commission.)

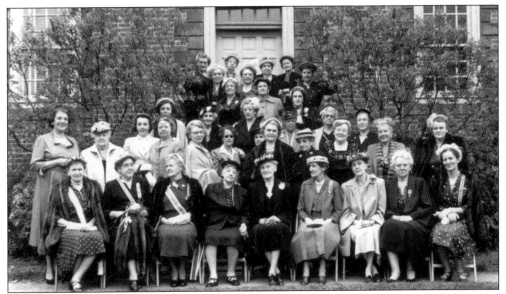

The Passaic County Park Commission purchased the Dey Mansion and the 56 remaining acres in 1930 as part of its plan for the Preakness Valley Park and Golf Course. The property is operated by Passaic County as a historic house museum. The museum hosts Revolutionary War encampments, reenactments, and historical group meetings, such as this 1947 meeting of the Daughters of the American Revolution. (Courtesy Passaic County Historical Society, *Paterson Morning Call* Collection.)

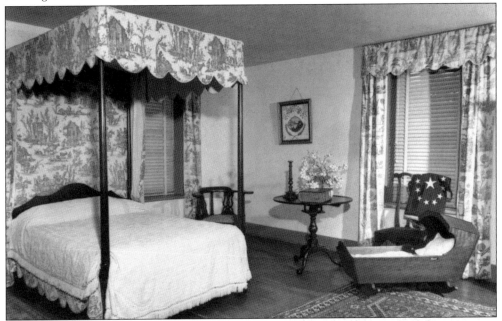

This photograph of the Dey Mansion second-floor bedroom was taken in 1959. All interior furnishings are characteristic of the Dutch Colonial style enjoyed by a gentleman farmer and his family during the last half of the 18th century, the period of Washington's residence. The manor house was listed on the National and State Registers of Historic Places in 1950. (Courtesy Passaic County Historical Society, *Paterson Morning Call* Collection.)

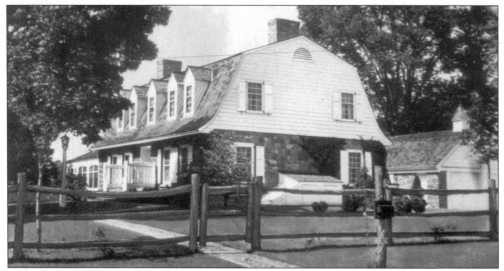

Samuel Van Saun purchased property in Preakness from original land patent holder C.H. Doremus in 1769. He completed his residence in 1770, a structure of hand-hewn beams and fieldstone walls, mortared with clay and straw. Van Saun, a farmer, selected the land at a natural spring, which feeds into the Singack Brook running behind the house. The brook supported the creation of a millpond and the operation of mills on the property. The homestead became the Aaron Laauwe Farm in the 19th century. (Courtesy Wayne Township Historical Commission.)

This photograph of the Van Saun house, taken in 1936 as part of a historic American buildings survey, records the influences of the Victorian-era architecture imposed on the Dutch Colonial farmhouse. Tall peaked roofs, long vertical windows with rounded tops, and stuccoed exterior surfaces altered the house beyond recognition. In 1948, the Mitchell family began restoration efforts and returned the home to its original Dutch Colonial exterior. (Courtesy Historic American Buildings Survey, Project No. 6-166.)

It is believed that Maj. Gen. Marquis de Lafayette was headquartered at the Van Saun farmstead in November 1780. Although evidence of his residence is unproven, the marquis was awaiting assignment and arriving troops from France while attending General Washington, who was in residence at the Dey Mansion. The farm, with its natural spring for fresh water, was located within one mile of the Dey estate. Genealogical records list the Van Sauns as parents of nine children in 1780. The original farmhouse, a one-room structure, probably assured Lafayette's sleeping arrangements on the grounds rather than in the home. (Courtesy Wayne Township Historical Commission.)

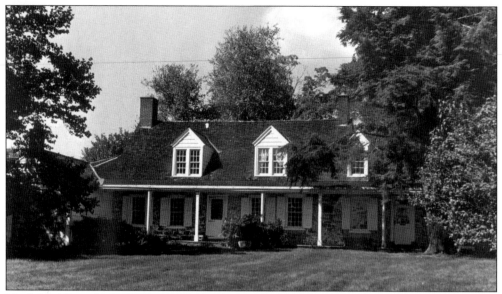

Uriah Van Riper built the Van Riper farmhouse upon his marriage to Polly Berdan, daughter of his nearest neighbor, in 1786. Tranquil pasturelands, rolling hillsides, and the anticipation of fertile soils created the perfect environment for their farmstead. The original farmhouse was a one-room fieldstone building, with cooking hearth and windows along the south side to gain the warmth of the sun. Twenty years later, as the farm gained modest success, a larger center-hall Dutch Colonial addition was constructed. (Courtesy Wayne Township Historical Commission.)

This scene of family and friends in the parlor of the Van Riper-Hopper House was taken in 1903. The images on the wall are charcoal-enhanced photographs of the last owners, Andrew Hopper and Mary Ann Van Riper-Hopper. (Courtesy Wayne Township Historical Commission.)

This *c.* 1950 photograph shows the Van Riper-Hopper barn, located north of the house, immediately before it was razed. In 1960, the house itself was threatened by planned construction of the Point View Reservoir by the Passaic Valley Water Commission. The house was saved by the efforts of the Wayne Township Historical Commission. Now owned by the Township of Wayne, the property is operated as a historic house museum. (Courtesy Wayne Township Historical Commission.)

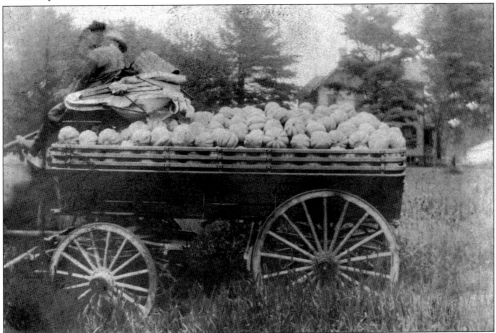

Operated as a dairy and vegetable farm, the Van Riper-Hopper farmstead produced grains, including hay and corn, and vegetables, including beans, squash, pumpkins, and cucumbers. Apple and peach orchards were located beneath the current reservoir. Ducks, geese, chickens, and swine filled the barnyard. Milk cows grazed the pastures. This *c.* 1905 photograph shows the produce wagon filled with squash on the way to market, probably in Paterson. (Courtesy Wayne Township Historical Commission.)

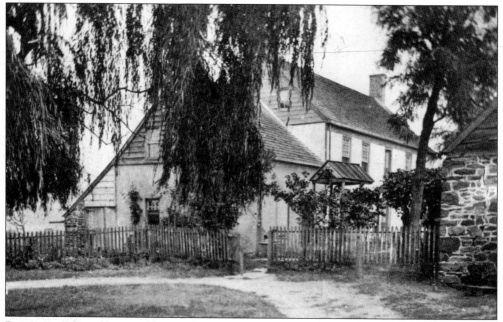

Between 1715 and 1720, the Berdan family bought 400 acres of land north of the Paterson-Hamburg Turnpike. This Berdan Homestead was built *c.* 1730 by one of the early Dutch settlers, Albert Berdan. This *c.* 1920 photograph shows the original well and smokehouse on the right. The larger, stuccoed, two-story structure was added to the original one-and-a-half-story, one-room house in the early 19th century. (Courtesy Wayne Township Historical Commission.)

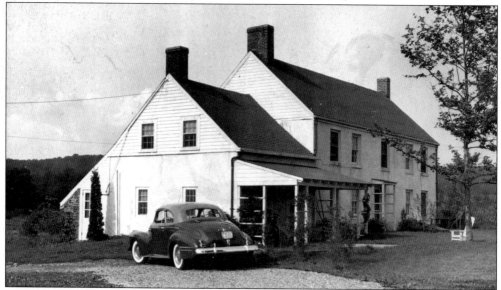

Except for the loss of exterior features (including the well, fence, and smokehouse) and the addition of a front porch, the Berdan residence looked largely unchanged in the 20th century. It is shown here in the late 1950s, shortly before its demolition for the construction of the Point View Reservoir. Only the foundation remains today, hidden beneath the reservoir. The original path of Berdan Avenue is also buried beneath the water. (Courtesy Wayne Township Historical Commission.)

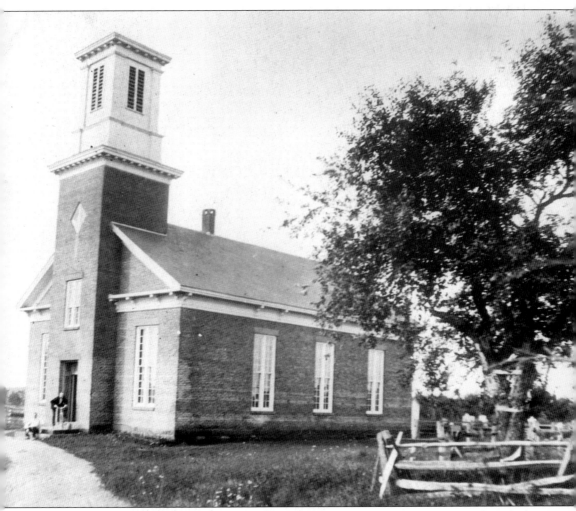

There are no known records of a "preaching station" or church in Preakness before the construction of the Preakness Reformed Church on Church Lane. Dutch settlers selected a prominent knoll, centrally located within the valley, for its site. Edo Merselis donated the grounds to the church in 1799. The first church, which stood on the spot from 1798 to 1852, was built of fieldstone and mortared with clay and straw, common building materials used for local farmhouses. The front doors were reportedly wide enough to permit entrance to a horse and wagon. A bell tower rose above the front doors and was crowned with a weathervane shaped to represent the Angel Gabriel. A second church was constructed on the site to accommodate a larger congregation. This brick structure, with tall vertical windows, was topped by a bell tower. A tragic fire in 1930 destroyed the second church, illustrated here in this 1910 photograph. By 1931, the church was rebuilt, and it still serves the community today. (Courtesy Wayne Township Historical Commission.)

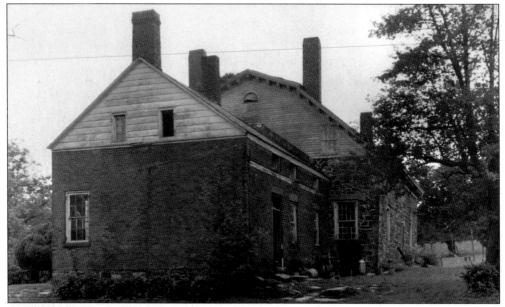

Photographed in 1936, the Edo Merselis house was built sometime after 1759, when he bought 70 acres of farmland from Robert Hunter Morris and additional acreage from Theunis Hennion. In 1769, his estate was increased by 210 acres purchased from Jan Berdan. Merselis was a captain of the New Jersey militia, a Bergen County freeholder, and a deputy to the provincial congress. His home, built in a pre-Revolutionary Dutch Colonial style, was that of a gentleman farmer, with wide center hallway and twin parlors. Located on the southeastern corner of Hamburg Turnpike and Berdan Avenue, the house was burned down by the Wayne Township Fire Department for practice training in 1961. (Courtesy Historic American Buildings Survey, No. NJ6-257.)

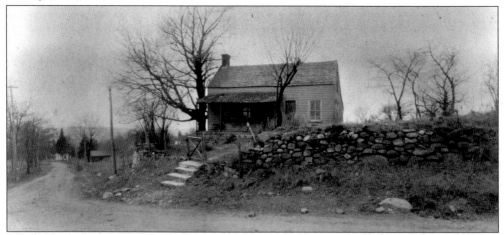

The Doremus house on Preakness Avenue was built c. 1760. Widely known as the Crow's Nest, it served as a hospital during the Revolutionary War. John Doremus filed a complaint with the Continental Army in November 1780, claiming that soldiers stole a two-year-old heifer, a beehive full of honeybees, and a flax tablecloth. The Doremus family is believed to have been residing in the Wayne area as early as 1717. Shown here in 1910, the house was demolished in 1968 for the widening and straightening of Preakness Avenue. (Courtesy Wayne Township Historical Commission.)

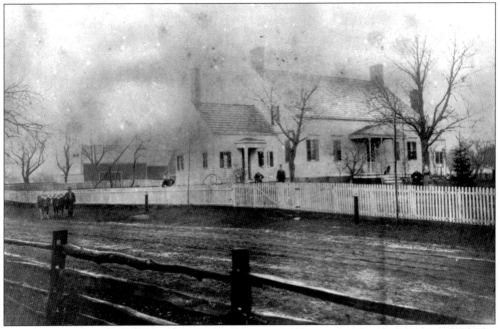

This Ryerson family property was an elegant and well-maintained farmstead in c. 1890. The large house with four chimneys, white picket fencing, and painted barns (visible at the rear left) indicates a prosperous farm. The house was built in 1810 and was located at the junction of Route 23 and the Newark-Pompton Turnpike until it was demolished for realignment of the highway.

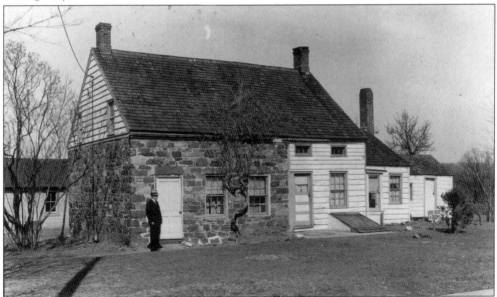

Photographed in 1938, this Van Riper house shows several additions to the right side of the house. The home was located on the Hamburg Turnpike between Alps Road and Jackson Avenue. The original one-room, one-and-a-half-story fieldstone dwelling on the left is typical of other 18th-century farmhouses in the Wayne area. (Courtesy Historic American Buildings Survey, No. NJ-218.)

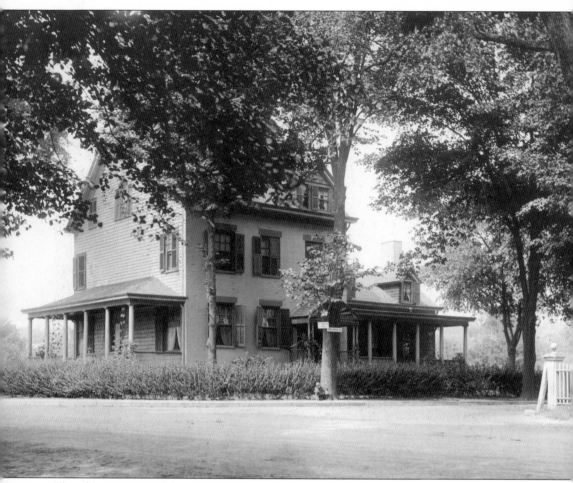

The oldest section of the Mead House, located on the Newark-Pompton Turnpike in Mead's Basin, was built in 1762. The larger, two-story section (seen on the left) was later added to the house. A fire on a Sunday morning in 1918 burned the home to the ground. The community fire cart was insufficient to fight the blaze. This ultimately proved a benefit of this devastating fire; it stirred the citizens to consider a new fire company. The Mead home was never rebuilt. In its place, a new brick schoolhouse, costing a princely sum of $160,000, was built. The building currently serves the community as a bank. (Courtesy Wayne Township Historical Commission.)

Two

GROWTH OF
MEAD'S BASIN

Servicing the needs of the local farming community, a small settlement was founded in the 18th century by John Mead, one of the original purchasers of the land patent with Arent Schuyler. The Mead family built a number of homes in the area.

Economic progress arrived with the Morris Canal Pompton feeder construction in 1836–1837. The purpose of the feeder was to bring water from Greenwood Lake into the Morris Canal system. The feeder linked Mead's Basin with the Pequannock and Ramapo Rivers in the northern part of Wayne. Iron, timber, coal, and food produce were shipped on the canal. In Mead's Basin, land owned by Isaac Mead was flooded to form a boat basin, which became a turnaround for canal boats. A general store, post office, blacksmith, and hotel served the canal traffic.

Construction of railroad lines into the community spurred the development of industries, including brick manufacturing and an explosive powder works factory. The Morris and Essex Railway Company built a freight line, which passed through Mountain View. It was leased to the Delaware, Lackawanna, and Western Railroad in 1869.

The Montclair Railway Company, which was later called the Greenwood Lake branch of the Erie Railroad, built a passenger line that extended into Wayne from the village of Montclair to the Hudson River at Pavonia Ferry. These rail lines contributed to the obsolescence of the Morris Canal, which was drained shortly after 1924.

Mead's Basin was renamed Mountain View in 1871. The railroad continued to bring passengers to the community. Many were seasonal visitors who came to enjoy the lake and river recreation. Canoeing, swimming, camping, and night life at the local community clubs drew vacationers from as far away as New York City.

The sleepy settlement of 12 buildings in the mid-19th century became, by the 1920s, a bustling community of 3,000 residents, about 400 of whom were daily commuters to New York, Jersey City, and Newark. Summer bungalows began to be converted to year-round homes when the motorcar became more prevalent.

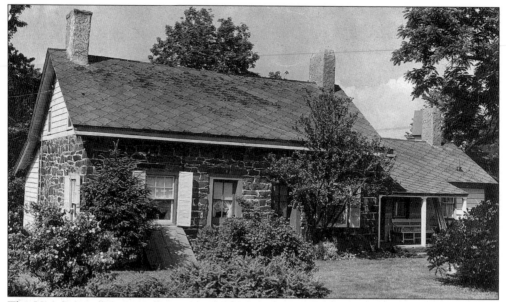

The Van Duyne house is shown in 1947 at its original location on Fairfield Road. Arent Schuyler sold the farmland to Van Duyne in 1704. The building is believed to be the second oldest house in Wayne. A cornerstone of the building marks the date 1706, but the house was probably built in the mid-18th century. (Courtesy Wayne Township Historical Commission.)

The structure became known as the Mead-Van Duyne House when it was sold to a member of the Mead family in the 19th century. This photograph shows the house at its present location on the grounds of the Van Riper-Hopper farmstead, where it was moved in 1974 after it was threatened by the widening of Route 23. The house is an excellent example of a symmetrical "mother-in-law" Dutch Colonial house, so named because two families could reside in the home with equal accommodations. (Courtesy Wayne Township Historical Commission.)

Situated along Fairfield Road on the way to Two Bridges, the one-and-a-half-story sandstone Demarest House, photographed in 1940, was built *c.* 1760 by John Ryerson and used as a parsonage for the Dutch Reformed churches. Sold to the Demarest family in 1814, it was dismantled in 1850 and completely rebuilt using the same materials because it was thought to be haunted. Despite its rebuilding, local residents continued to report seeing unusual lights flashing in the second-story windows. (Courtesy Wayne Township Historical Commission.)

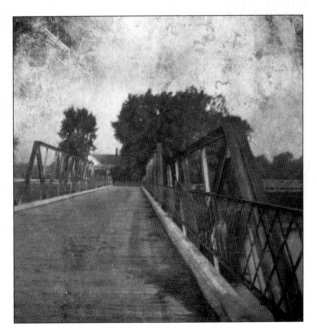

This photograph of the former iron bridge at Two Bridges shows the Derrick Dey Tavern in the rear. The Derrick Dey Tavern, the house of Thomas Dey, and the two bridges are noted on a 1780 military map prepared by Robert Erskine. The tavern served as the headquarters of Col. Charles Stewart and the army post office in November 1780, while Washington was headquartered at the Dey Mansion. An important crossroads for troop movements during the Revolution, archaeological evidence shows that Native Americans traveled the Two Bridges area as early as 10,000 years ago. (Courtesy Wayne Township Historical Commission.)

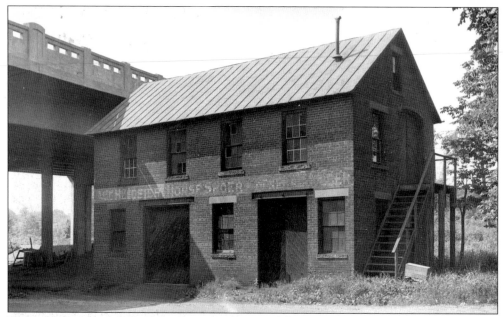

To service the canal traffic following construction of the Morris Canal, Cornelius Jacobus built and operated a blacksmith shop on Boonton Road in Mead's Basin. The blacksmith was a necessity in the 18th and 19th centuries. He shoed horses and the mules that pulled the barge boats, as well as making and repairing all types of iron, from kitchen pots to farm tools and hardware. Photographed in 1960, the shop was demolished in the late 1970s for the widening of elevated Route 23. (Courtesy Wayne Township Historical Commission.)

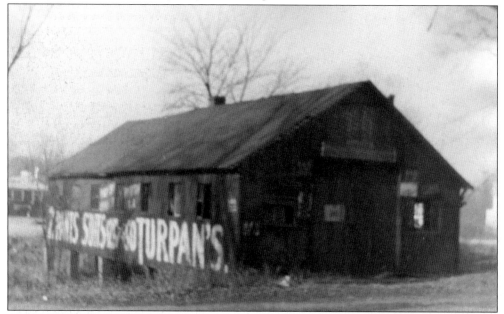

A second blacksmith shop was built in Mountain View by Dick Husk *c.* 1900; it was located on the Newark-Pompton Turnpike, later Boonton Road, across from the United Methodist Church. Husk also worked with a wheelwright to repair wagons and carriages. (Courtesy Wayne Township Historical Commission.)

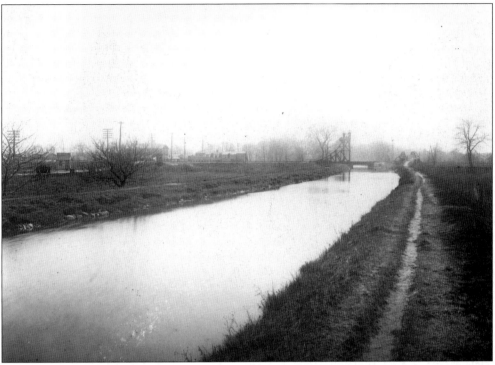

This view of the Morris Canal Pompton feeder in Mountain View was taken in 1900. The towpath for mules is shown on the right, and Mountain View Boulevard is on the left. The cantilevered bridge for the New York and Greenwood Lake Railroad seen in the distance was raised to allow barge boats to pass. (Courtesy Wayne Township Historical Commission.)

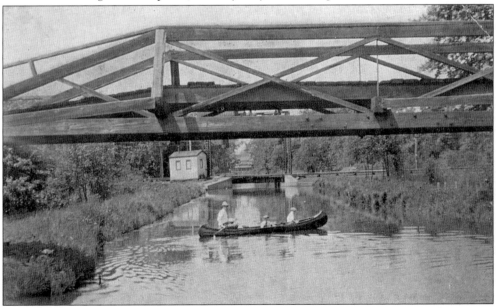

This c. 1920 view of the feeder shows the pedestrian bridge in the foreground and the railroad bridge in the background. Mule barge traffic was nonexistent by this time, and residents utilized the feeder for canoeing and swimming. (Courtesy Wayne Township Historical Commission.)

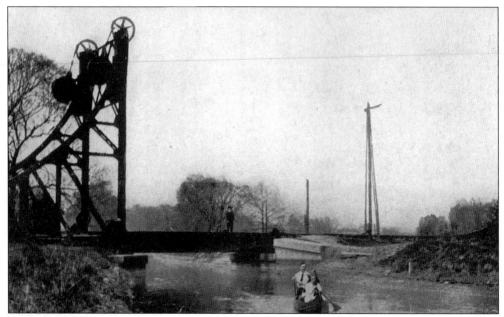

A cantilevered drawbridge was constructed across the canal in Mountain View to accommodate the Erie Railroad. By a system of pulleys and weights, the bridge could be raised to permit canal traffic to pass through. (Courtesy Wayne Township Historical Commission.)

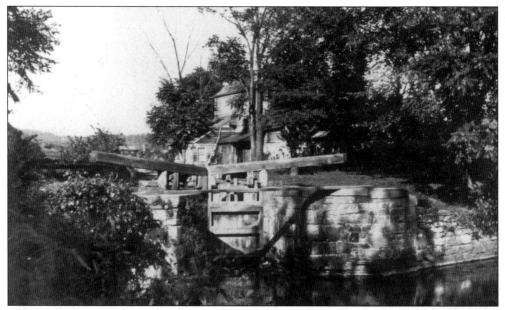

The guard lock between the Morris Canal Pompton feeder and the Pompton River was photographed in 1920. The lock kept the fluctuation in water levels of the river from affecting the feeder. The lock tender's house can be seen on the right. (Courtesy Wayne Township Historical Commission.)

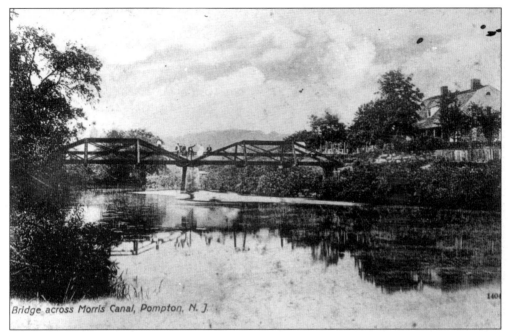

Bridge across Morris Canal, Pompton, N. J.

The Colfax Bridge crossed the Ramapo River section of the Morris Canal Pompton feeder south of the Schuyler-Colfax House, seen on the right in this c. 1910 postcard view. The towpath followed the eastern shore. (Courtesy Wayne Township Historical Commission.)

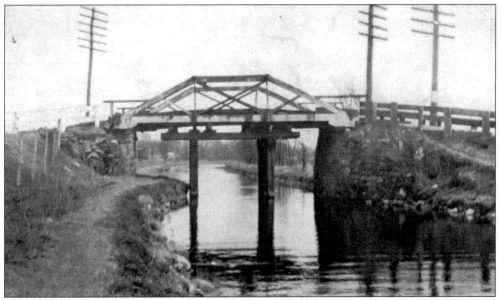

Photographed in 1910, the Parish Drive Bridge over the Morris Canal Pompton feeder in Mountain View required extra structural support for its span of the canal. Note the masonry abutments and the wooden piers. (Courtesy Wayne Township Historical Commission.)

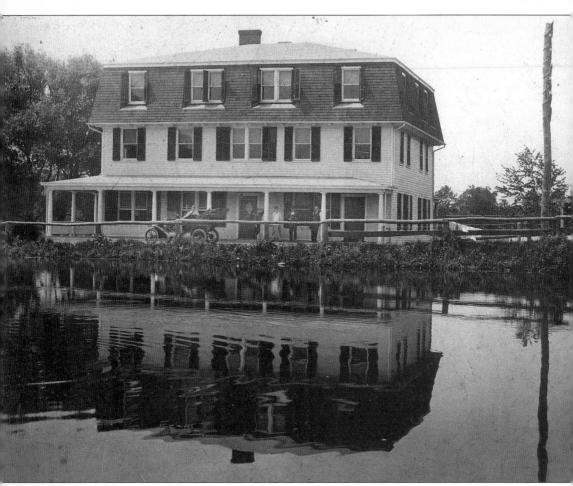

Built in 1909 on the site of an earlier hotel servicing Morris Canal travelers, the three-story mansard-roofed Hixon Hotel is shown here shortly after its completion. The proprietor, Joseph Hixon, stands third from the left on the front porch. Hixon rented out the hotel to a succession of managers, creating multiple name changes, until it finally became the Mountain View Hotel. The hotel continued to serve travelers after the demise of the canal. In the early 20th century, the railroads brought vacationers to the community to enjoy the recreational opportunities provided by nearby rivers and lakes. Currently named Gabriel's, the establishment continues to be a popular destination for food and nightly entertainment. (Courtesy Wayne Township Historical Commission.)

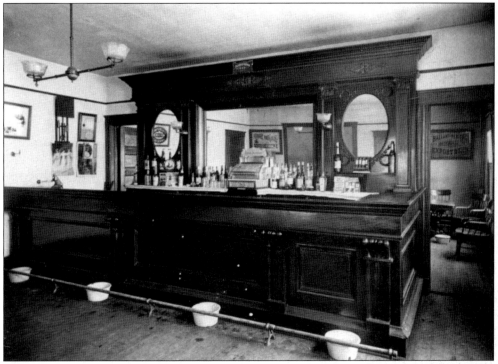

This interior view of the bar in 1912 shows the elegant woodwork and gas lighting, which defined the new hotel as a luxury establishment in the Wayne rural farming community. (Courtesy Wayne Township Historical Commission.)

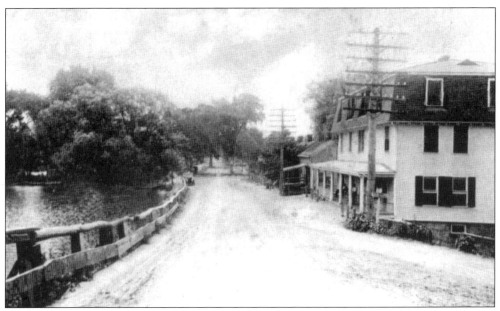

This 1915 scene of Mountain View looks south on the unpaved Newark-Pompton Turnpike. The Hixon Hotel is on the right, and the canal basin turnaround is on the left. (Courtesy Wayne Township Historical Commission.)

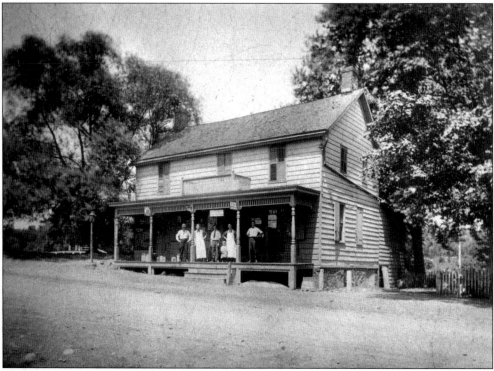

Brothers Nathaniel and Jacob Wilson, anticipating an economic boom in the Mead's Basin area with the advent of the Morris Canal, purchased land on which they built a two-story wood-frame general store in 1828. Nathaniel Wilson served as postmaster of the post office also established in the building in 1829. This 1912 photograph of the building shows the general store owner William Shackleton in center. (Courtesy Wayne Township Historical Commission.)

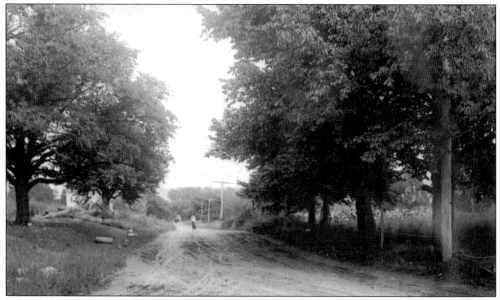

This *c.* 1910 postcard view of the country lane leading away from Mountain View toward Preakness typifies the rural atmosphere of turn-of-the-century Wayne. (Collection of the author.)

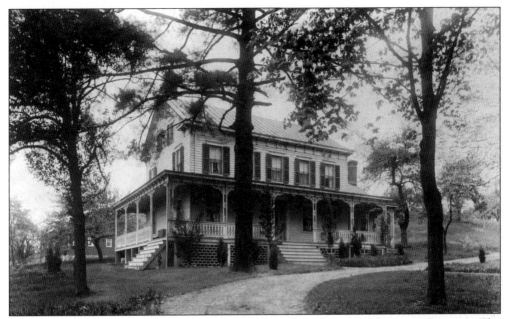

The Forsburg house, shown *c.* 1910, was built in the 1830s on Edgemont Crescent. The Victorian detailing of the home was added in the late 19th century. Possibly built to capitalize on the increased economic climate that the Morris Canal brought to Mead's Basin, the building may have been used at one time as a store. The house was demolished in 1981 for the widening of Route 23 and construction of the Alps Road entrance ramp. (Courtesy Wayne Township Historical Commission.)

Frederike and Harold Mumford rented the Forsburg house in 1915 and 1916. The Willow Tea House restaurant was established in the Forsburg house by Mrs. Mumford in 1915. This advertisement was printed in the local newspaper. (Courtesy Wayne Township Historical Commission.)

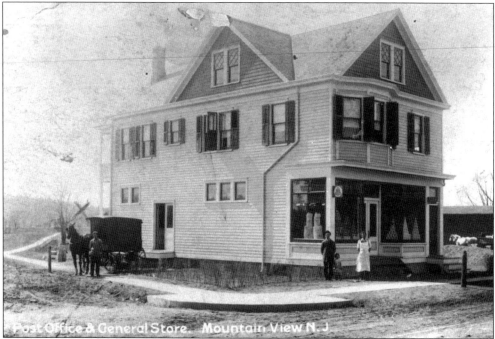

This photograph of the Hammond building was taken shortly before 1911. After working as a store clerk, Harry Hammond opened a general store in Mountain View on Newark-Pompton Turnpike across from the Mead House. The store also housed the post office (Mrs. Hammond became the postmistress) and the first telephone in the area. The family lived upstairs over the store. (Courtesy Wayne Township Historical Commission.)

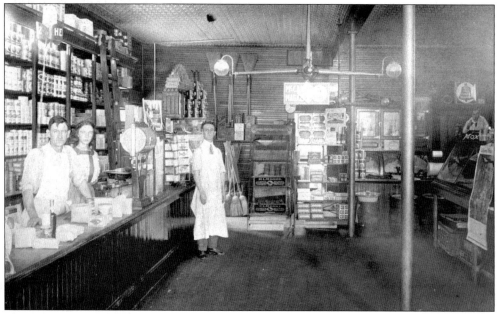

The interior of the Hammond General Store is pictured c. 1918. From left to right are Charles Hammond, Lena Vander Wende, and Harry Hammond. (Courtesy Wayne Township Historical Commission.)

Standing outside the Hammond General Store (a popular community gathering spot) are, from left to right, Clarence Fullard, an unidentified friend, and Elmer McCracken, who were photographed in 1924. The new brick Mountain View School is visible in the background. (Courtesy Wayne Township Historical Commission.)

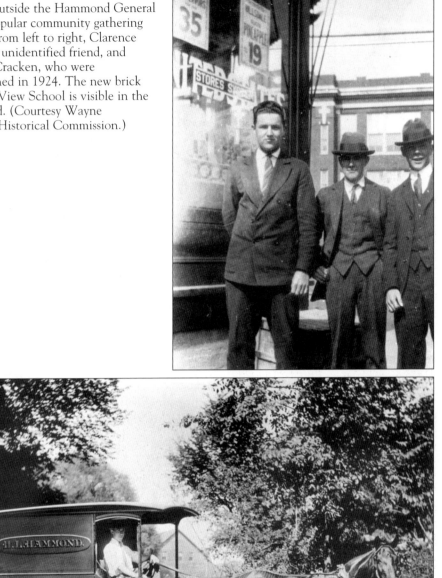

The Hammond General Store made local deliveries. This photograph of the horse-drawn delivery wagon was taken *c.* 1912. Dan Johnson was the driver. (Courtesy Wayne Township Historical Commission.)

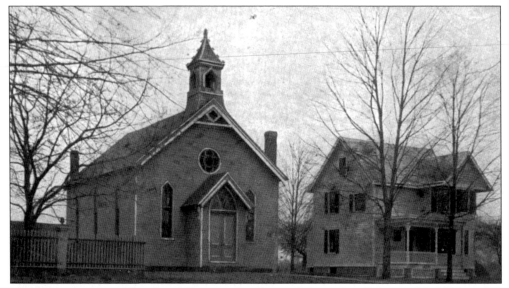

The Mountain View Church, on Boonton Road, was dedicated on February 24, 1883, with a congregation of 27. The parsonage, to the right of the church in this 1910 postcard view, was built in 1904. (Courtesy Wayne Township Historical Commission.)

The original church was replaced by the United Methodist Church building in 1916. The church moved in 1965 to a newly designed building on Parish Drive. The parsonage was moved in 1985 to the corner of Lewis Street and Holy Cross Way. (Courtesy Wayne Township Historical Commission.)

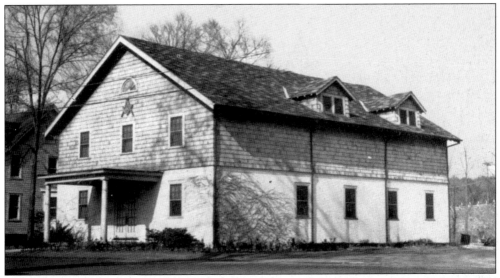

The Mountain View Masonic Lodge No. 252 building was located adjacent to the Methodist Church parsonage on the corner of Boonton Road and Taylor Drive. The organization was chartered in 1925 and moved into its new building in 1930 with a membership of more than 200 Masons. (Courtesy Wayne Township Historical Commission.)

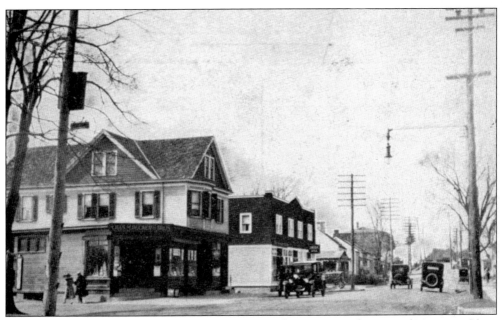

In this view, looking north on Boonton Road from the commercial center of Mountain View in 1925, motorcars and electric lights have replaced the horse and wagon and gaslights. (Courtesy Wayne Township Historical Commission.)

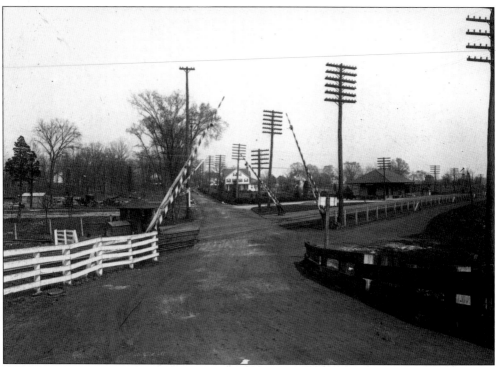

This c. 1920 view of Parish Drive shows the Lackawanna Railroad Station on the right. The current viaduct was not constructed until 1939. The Little house is visible in the center rear. Madge Little married Wayne inventor, millionaire, and philanthropist LeGrand Parish. (Courtesy Wayne Township Historical Commission.)

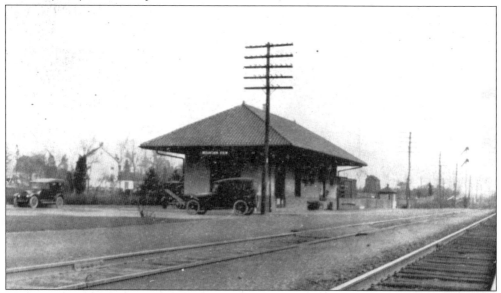

The Morris and Essex Railway Company began to purchase land for the railroad in 1869. It was leased in 1871 to the Delaware, Lackawanna, and Western Railroad. The Boonton line, which traveled through Mountain View, was established as a freight line. (Courtesy Wayne Township Historical Commission.)

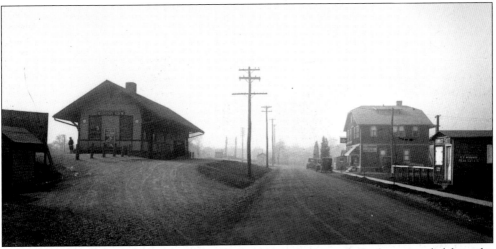

In 1870, the Montclair Railway Company began to construct a railway that extended from the New York and New Jersey line near Greenwood Lake across New Jersey to the Hudson River adjacent to New York City. Looking north in 1900, this view of Greenwood Avenue shows the Mountain View passenger station on the left and John Beal's confectionery store on the right. (Courtesy Wayne Township Historical Commission.)

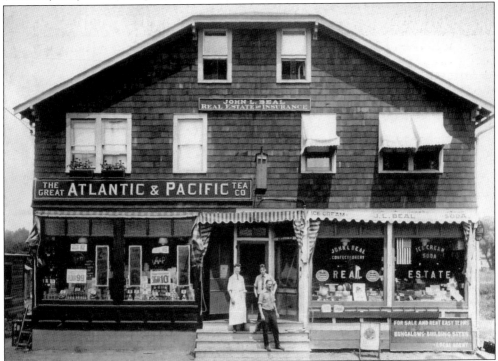

This 1909 photograph shows John Beal standing in front of the Beal Building in Mountain View. His location adjacent to the trail station helped Beal grow his business. Beal operated a confectionery store on the first floor and leased space to the forerunner of the supermarket, the Great Atlantic & Pacific Tea Company. Beal also rented and sold real estate. Many properties were seasonal vacation homes and bungalows along the nearby rivers. (Courtesy Wayne Township Historical Commission.)

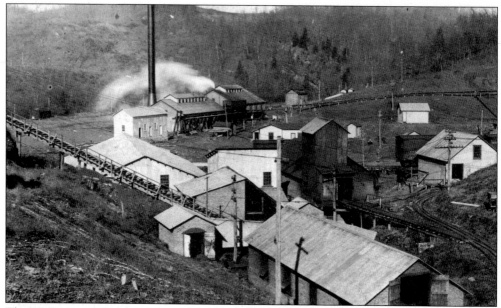

This 1900 postcard image shows a factory nestled in the rural Wayne countryside. The factory was built *c.* 1869 by the Laflin and Rand Powder Company to manufacture explosives and explosive powders. Known then as the Passaic Mills, the factory manufactured up to 600 kegs of powder a day and had expanded to 15 buildings and storage magazines by 1882. Explosions on the site were devastating. In 1887, an explosion killed three workers and broke windows as far away as the city hall in Elizabeth. (Courtesy Wayne Township Historical Commission.)

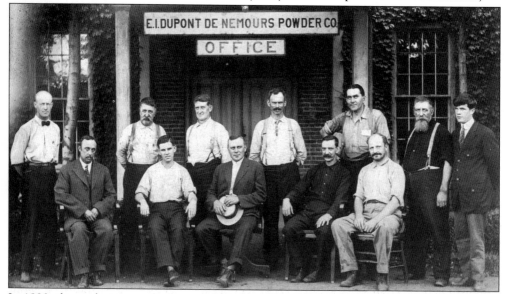

In 1890, the explosive powder factory was sold to E.I. du Pont de Nemours & Company. This photograph, taken *c.* 1915, shows the managers and supervisors of the manufacturing facility. A Mr. Holcomb, supervisor of the factory, is seated in the center. Another devastating explosion in 1901 killed three workers and caused monetary losses totaling $60,000. The company continued to produce explosive powders through the end of World War II in Wayne. (Courtesy Wayne Township Historical Commission.)

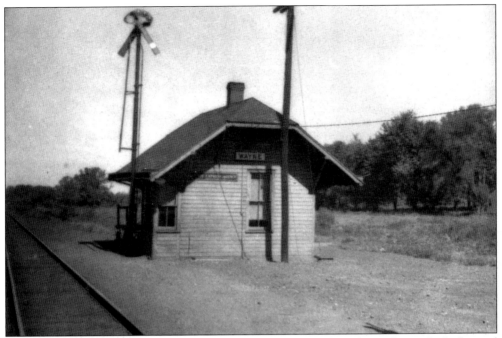

Shown in 1900, this small Wayne station on the Erie Railroad was located near the Laflin and Rand Powder Company. (Courtesy Wayne Township Historical Commission.)

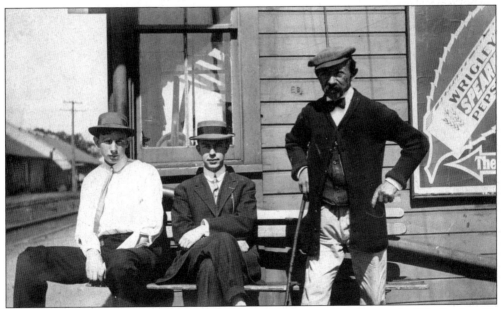

Workers are waiting for the train arrival in this 1915 photograph taken at the Erie Station. By 1901, the powder works employed more than 100 workers, some of whom commuted to work by train. The man on the far right is a Mr. Sauter, a repairman at the factory. (Courtesy Wayne Township Historical Commission.)

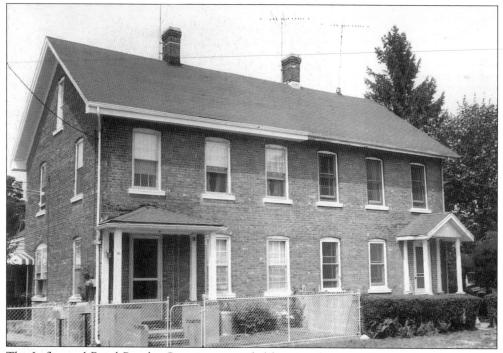

The Laflin and Rand Powder Company provided housing for supervisors and workers at the turn of the 20th century. Two-story, brick row houses were built along Ford Street to provide multifamily housing for workers and their families. (Courtesy Edward J. Lenik.)

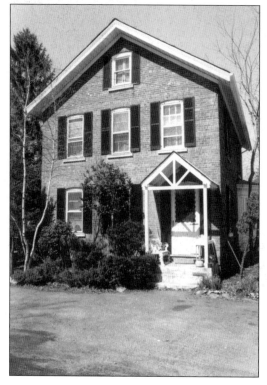

Single-family housing was provided for supervisors and their families. This 1980 photograph illustrates minimal changes in the architecture since 1900. The bricks for the construction were manufactured at the nearby Standard Brickyard. (Courtesy Edward J. Lenik.)

This view of the Lafflin and Rand Powder Company site on Ryerson Avenue shows the large brick factory buildings later operated by Mack-Wayne. (Courtesy Edward J. Lenik.)

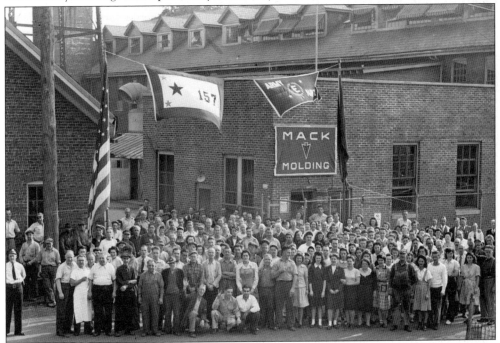

The Mack-Wayne Plastics Company was one of the largest independent plastic molders in the United States in the mid-20th century. In the mid-1920s, Mack-Wayne purchased two powder works manufacturing buildings, which were then retooled to produce molded plastics. Mack was the leading supplier of plastics for war materials during World War II. This photograph of the Mack-Wayne buildings and employees was taken c. 1950. (Courtesy Wayne Township Historical Commission.)

At least six brickyards were in active operation in Wayne between 1870 and 1930. An average day during the busy season of May through October yielded 30,000 bricks in 1882. The clay in Wayne was about 20 feet thick and was considered to be of the best kind. This 1910 photograph, taken at the Hosier Brick Company, shows William Hosier seated at left and Garret Bailey seated at right with the crew. (Courtesy Wayne Township Historical Commission.)

The Hosier Brick Company was located in the current North Cove recreational area. This tempering pit in 1910 mixed the clay, sand, water, coal dust, and red ochre for the required six hours, until a consistency of putty was attained. Horsepower and later steam drove these ring pits. (Courtesy Wayne Township Historical Commission.)

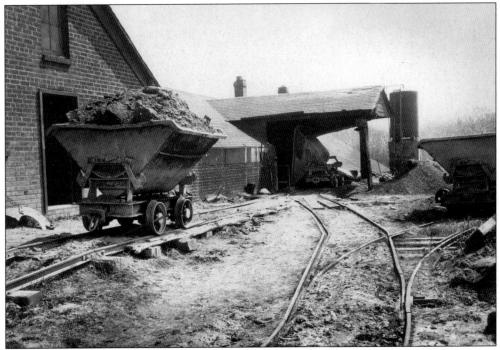

The last brick company in Wayne, the Paterson Brick Company (also known as the Passaic County Brick Company), closed its manufacturing facilities in 1962. Much of the land owned by the manufacturer was used during construction of Route 80. This *c.* 1960 photograph shows the clay carts that were used to move the clay in the brickyards. (Courtesy Wayne Township Historical Commission.)

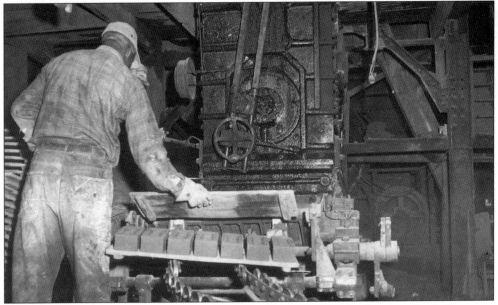

This interior view shows the automatic brick machine in use at the Paterson Brick Company in 1960. This piece of machinery was used to form the brick, replacing the older hand methods. (Courtesy Wayne Township Historical Commission.)

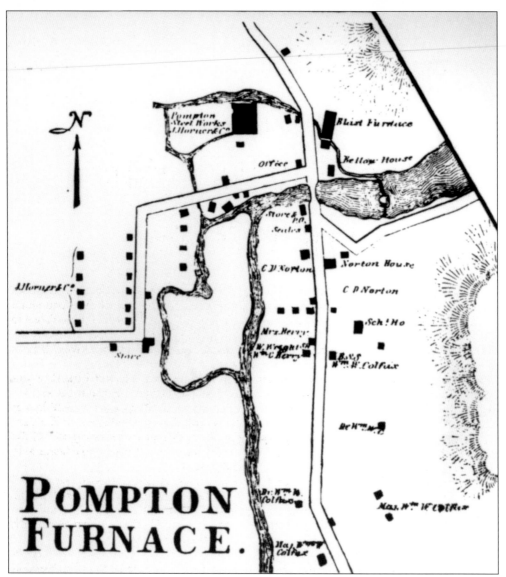

POMPTON FURNACE.

This detail of the Pompton Ironworks, located on the Paterson-Hamburg Turnpike at the Wayne-Pompton Lakes Border, is illustrated in the 1861 map of Bergen and Passaic Counties. Arent Schuyler's son Phillip probably built the original ironworks. Family history suggests that the iron furnace supplied cannonballs and shot during the French and Indian War in the 18th century. Sold to the Ogden family in 1744, the furnace continued to produce ammunition for General Washington's troops during the Revolutionary War. The manufacture of cannonballs and shot was considered so vital that workers were exempt from military service. Following the war, the furnace and all its associated buildings were purchased by Martin Ryerson, who supplied the American forces during the War of 1812.

Three

TRAVELING THE HIGHWAYS

The transportation highways in Wayne Township can be documented as early as the mid-18th century on the military maps drawn by Robert Erskine, the cartographer of the Continental Army. The primary routes included roads we know now as Terhune Drive, Paterson-Hamburg Turnpike, Berdan Avenue, Black Oak Ridge Road, Ratzer Road, Valley Road, Totowa Road, Preakness Avenue, Newark-Pompton Turnpike, Fairfield Road, and Parish Drive. Many of these roads began as the footpaths of Native Americans.

On March 12, 1806, an act of the New Jersey state legislature incorporated the Paterson-Hamburg Turnpike. Completed in 1809, the turnpike was constructed four rods wide, which is about 66 feet using today's unit measurement. Beginning at the Acquackanonk Landing at Passaic in the south, it passed through Paterson, Wayne, and Pompton and ended in Hamburg at the border of Sussex and Bergen Counties in the north. A busy center of commerce, the turnpike carried iron products from the Ringwood and Pompton iron furnaces and produce from local farms to the markets in Paterson, Hoboken, and Jersey City.

The turnpike was a toll road monitored by toll keepers. A pike, or pole, was erected horizontally across the roadway at regular intervals to prohibit travel. After the required toll was paid, the pike was turned to permit passage. Wagons were charged 1¢ per mile per horse (up to four horses), and a horse and rider were charged 1/2¢ per mile. The Deckertown Stagecoach made a round-trip from one end of the turnpike to the other, three times a week.

The Newark-Pompton Turnpike was also incorporated in 1806. The two highways were in competition with each other as major thoroughfares through the community. The Newark-Pompton Turnpike intersects the Hamburg Turnpike in Riverdale in the north. It brought travelers, goods, and produce through Pequannock Township across the Pompton River, through Mead's Basin and south through Cedar Grove and on to Newark.

The 20th century brought motor vehicle travel and the construction of Route 46 and, in 1936, Route 23. In the 1960s, due to the increased congestion of the roadways, traffic circles were eliminated, the thoroughfares were widened into superhighways, and Route 80 was constructed in Wayne Township.

This chapter begins by traveling south on the historic Hamburg Turnpike, visiting the Newark-Pompton Turnpike in Mountain View in the early 20th century, and ends with images of the beginnings of the superhighway landscape.

In this image looking north in 1900, the Paterson-Hamburg Turnpike retains the charm of a country road even after it was improved and straightened in 1877. The Colfax farm lies behind the fence on the left. The family barn on the right was destroyed by arson in 1910. (Courtesy Wayne Township Historical Commission.)

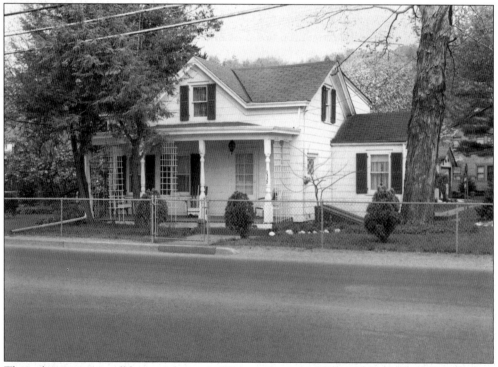

The only remaining toll keeper's house in Wayne, photographed in 1960, is located on the east side of the turnpike across from the Schuyler-Colfax House. (Courtesy Paterson Museum, *Paterson Evening News* Collection.)

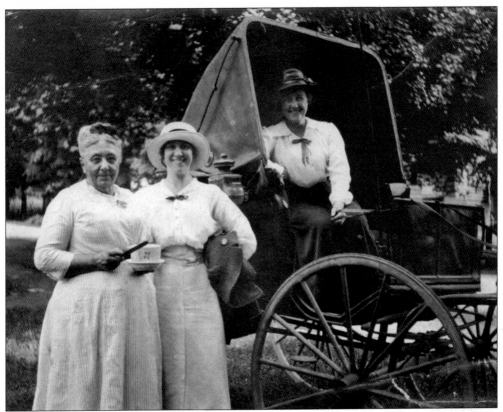

These women are returning from a carriage ride on the turnpike in 1910. Adelia Roome Colfax (left) was the mother-in-law of Angie Wells Colfax (in the carriage). Blanch Colfax (center) was the wife of William Schuyler and Angie's daughter-in-law.

In this early-20th-century view (looking north toward Pompton), the first motorcars begin to travel the Paterson-Hamburg Turnpike. (Courtesy Wayne Township Historical Commission.)

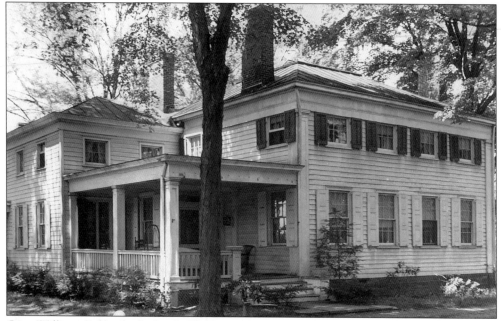

Gen. William Colfax built the Colfax-Dawes House in 1814 for his son George Washington Colfax. The latter was the grandfather of the owner in 1936, when this photograph was taken. George Washington Colfax was the godson of Pres. George Washington, who attended his christening when Washington was still a general. The house was moved from its Hamburg Turnpike location to the Dawes Highway in the 20th century. It was demolished in 1998. (Courtesy Historic American Buildings Survey, No. NJ-6-123)

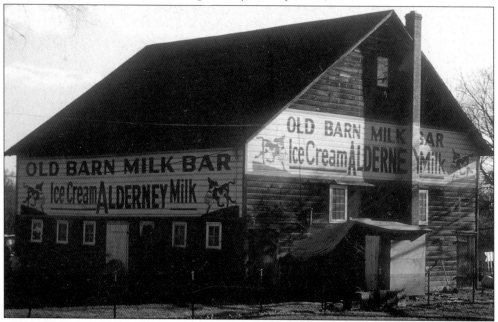

The Alderney Milk Barn, just south of the Schuyler-Colfax House, was originally a Colfax barn. Photographed in 1950, the barn served as an ice-cream stand and seasonal restaurant. Today, it remains a popular ice-cream stop. (Courtesy Wayne Township Historical Commission.)

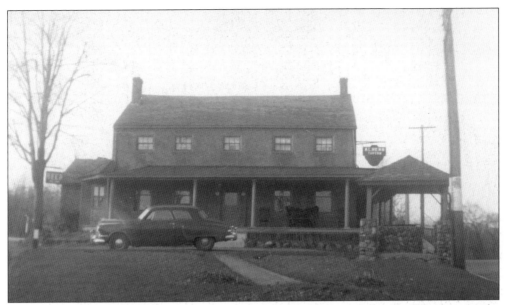

Al Henn's Tavern, originally known as the Half-Way House, provided rest and food service for weary stagecoach passengers traveling the Paterson-Hamburg Turnpike in the early 19th century. Located on the corner of Jackson Avenue, the tavern was purchased by Al Henn's father and remained in the family for almost 100 years, until it was demolished in 1968. (Courtesy Wayne Township Historical Commission.)

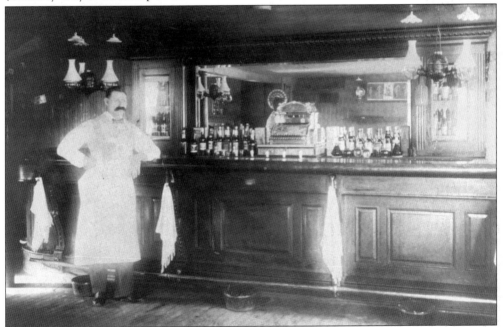

This photograph of the barroom at Al Henn's Tavern was taken in 1900. The tavern was famous as one of the finest ale houses in northern New Jersey, serving genuine Camden cream ale. The body came out of a copper kettle, and the head was poured from a tap. The customers were a mix of local residents and travelers—well-dressed men, farmers, trades people, or laborers, all rubbing elbows at the bar. (Courtesy Wayne Township Historical Commission.)

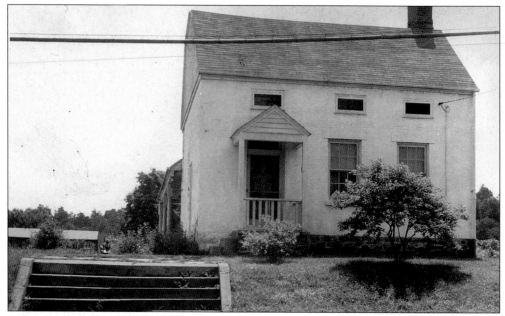

The incorporation of Wayne Township in Passaic County, resulting from the subdivision of Manchester Township, occurred on April 12, 1847, in the home of William Casey. Henry Casey and Hannah Haycook purchased land, for $400, in March 1846, which was part of the original Schuyler patent. This 1947 image is closer to the original design of the house, which later became the Jackson Inn. Note the concrete stairs, the only remaining vestige of the inn. (Courtesy Wayne Township Historical Commission.)

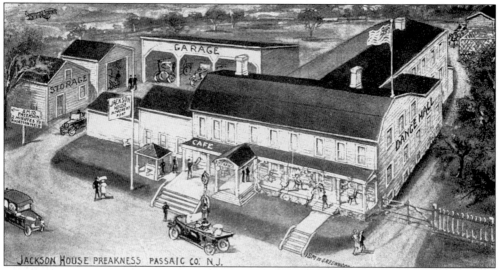

The Jackson House Inn was constructed from the original Henry Casey house, along with several large additions. In the early 1900s, the proprietor, William Mathews, operated a hotel with a cafe and dance hall. Garages were available for the new motorcars. This postcard image notes the direction of Murchio's Airport, which attracted thousand of visitors on weekends to watch the barnstorming and parachuting events. Wayne was becoming a vacation paradise offering recreation activities at local rivers, lakes, and picnic groves. This hotel appears ready to serve the influx of expected visitors. (Courtesy Wayne Township Historical Commission.)

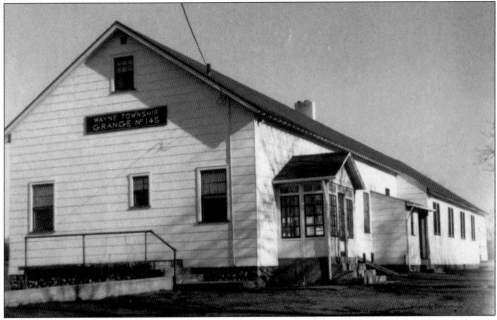

The Township of Wayne Grange No. 145 was organized on April 7, 1904. Built on the Hamburg-Paterson Turnpike adjacent to the Upper Preakness School in 1906, the Grange was an organization of farm families. The group supported charitable causes and 4-H activities, organized community projects, assisted the Red Cross and sold Victory and Liberty Bonds during wartime. The original Grange hall was destroyed by fire in 1928 and rebuilt. The structure was demolished in 1980 for construction of the Church Lane intersection. (Courtesy Wayne Township Historical Commission.)

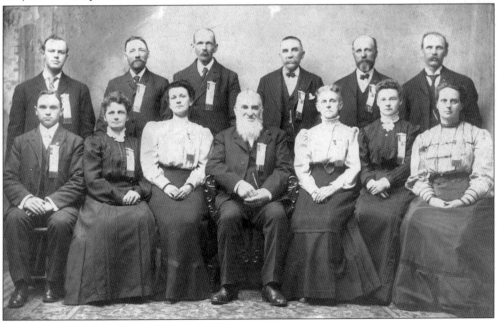

The first Seventh Degree members of the Wayne Township Grange No. 145 were photographed in 1910. (Courtesy Wayne Township Historical Commission.)

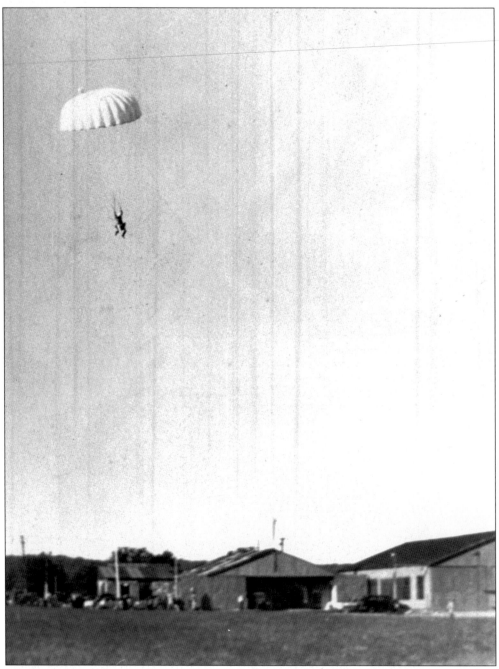

Murchio's Airport was built in 1919 on the corner of the Paterson-Hamburg Turnpike and Church Lane. It was one of the oldest established airports in New Jersey. The others are Teterboro Airport and Bader Airport in Atlantic City. All three started in the same year. Thomas Murchio ran the airport and organized the barnstorming and daredevil flying events. Crowds came on Sunday to watch parachute jumper Bill Rhode, called the Smiling Daredevil, who still holds the record for jumping with five parachutes at Murchio's in 1938. (Courtesy Wayne Township Historical Commission.)

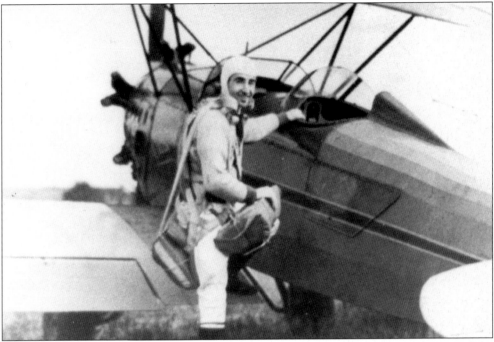

Daredevil Bill Rhode prepares for a parachute jump in 1938. Rhode was a member of the Suicide Club, a group of five parachute jumpers who worked in air circuses and exhibitions. A Wayne resident, Bill later earned the Distinguished Flying Cross and the Air Medal during World War II. (Courtesy Wayne Township Historical Commission.)

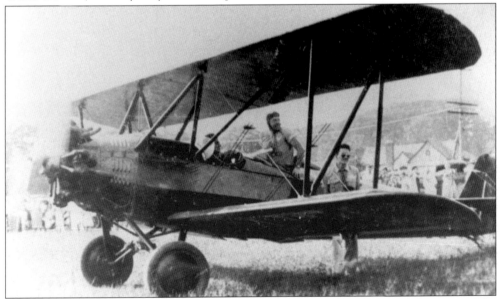

This view shows a typical Sunday crowd scene at Murchio's Airport in the 1930s. The Command-Aire biplane is loading passengers for a flight. Passengers were charged $1 for each ride. During the Great Depression, barnstormers performed dangerous tricks in an attempt to make money. The $1 ride was a costly expense in the 1930s. Murchio's was sold in 1956, following the death of Thomas Murchio. (Courtesy Wayne Township Historical Commission.)

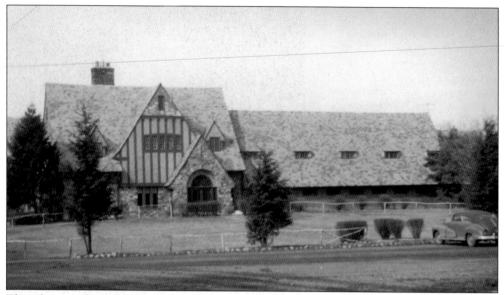

This photograph of the North Jersey Country Club on Hamburg Turnpike was taken c. 1947. Organized in 1897, the origins of the club reach farther back, to 1894, when a golf club was started in Paterson. In 1921, 327 acres of the Greenbrook farm were purchased for a new club after the original clubhouse burned down. Architect Walter J. Travis designed the golf course. The massive clubhouse, designed by architect Clifford C. Wendeback in 1922, is constructed of local fieldstone, timbers, and stucco with a slate roof. (Courtesy Paterson Museum, *Paterson Evening News* Collection.)

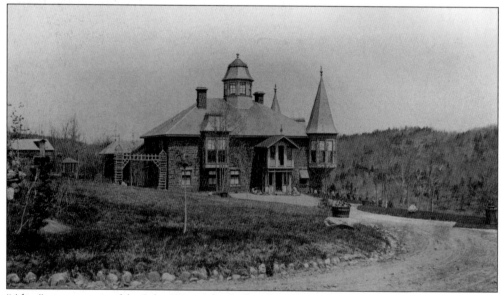

"Alisa" was conceived by John Watt MacCullough, a Scottish immigrant and Paterson wool industrialist, as a grand refuge from the urban manufacturing centers of the late 19th century. Named after Alisa Crags, a remote Scottish island of verdant forests and rocky landscapes, the hilltop on the Paterson-Hamburg Turnpike must have reminded MacCullough of his homeland. This 1878 photograph illustrates the unusual architectural details of the residence. (Courtesy Wayne Township Historical Commission.)

In 1902, the widow of Garret Hobart purchased Alisa at auction. Vice president of the United States (serving with Pres. William McKinley), Hobart died in office at the age of 55. Hobart was a prominent Paterson citizen, attorney, political leader, and first president of the neighboring North Jersey Country Club. (Courtesy Paterson Museum.)

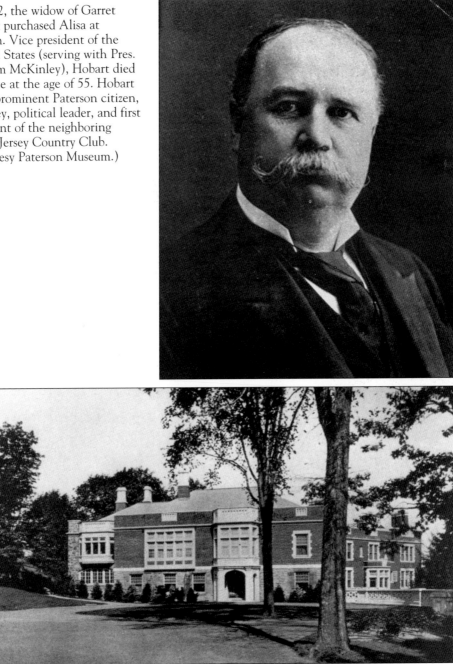

Esther Jane, Hobart's wife, presented the estate to her son Garret Hobart Jr., who proceeded to add adjacent properties to the estate, changing the name to Alisa Farms. In 1938, Hobart Jr. purchased the adjacent Gaedes estate and added a three-story brick wing, creating a 40-room mansion reflective of the family wealth and social position. After the death of Hobart's son, the estate was sold to the state for construction of a teacher's college. William Paterson University now occupies the estate. The school restored the house to its original exterior appearance and renamed the house Hobart Manor. (Courtesy Wayne Township Historical Commission.)

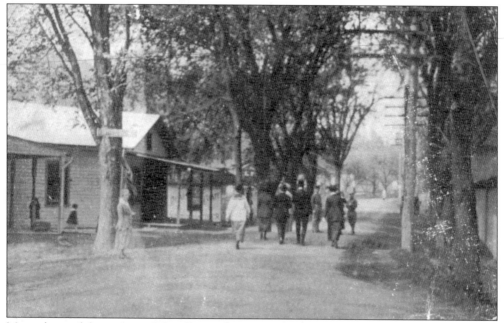

Many thoroughfares retained the charm of a country lane well into the 20th century. Boonton Road in Mountain View is shown in 1910. The motorcar had not yet arrived, and the Sunday afternoon stroll remained popular. (Courtesy Wayne Township Historical Commission.)

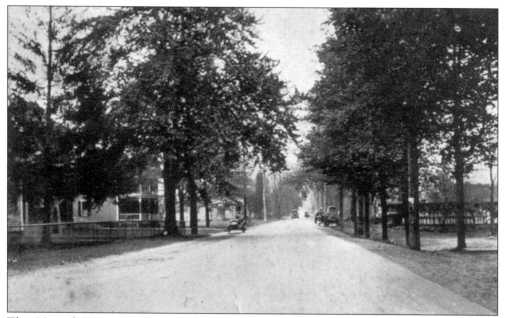

The Newark-Pompton Turnpike was a major transportation highway that increased commercial development in Mountain View. The turnpike crossed the Pompton River in Pequannock Township and merged with Route 23 in Mountain View. This scene in 1920 marks the arrival of the motorcar. (Courtesy Wayne Township Historical Commission.)

The motor vehicle's arrival in the early 20th century strained the road system in Wayne Township. Most country lanes and even major transportation arteries were unpaved. In 1936, the construction of Route 23 played a major role in moving goods and travelers north and south along the western portion of Wayne. The path of the construction merged much of the Newark-Pompton Turnpike with Route 23. (Courtesy Wayne Township Historical Commission.)

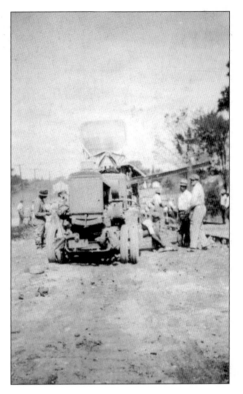

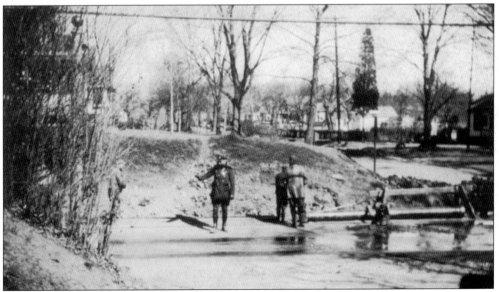

Construction of the widened, paved surface of Route 23 provided much needed jobs during the Great Depression. (Courtesy Wayne Township Historical Commission.)

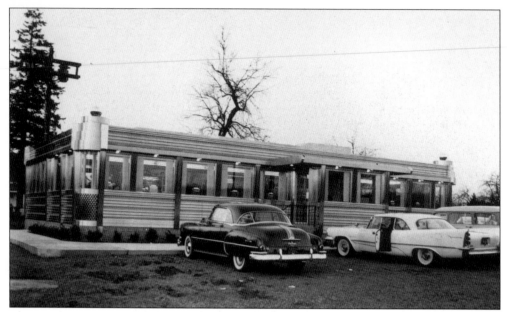

The newly paved roads attracted business. Retail stores, gas stations, and highway food establishments lined the highways. The highway diner, later to become a New Jersey classic, was a popular destination in Wayne. This 1962 view of a Route 23 diner is typical of the shiny stainless-steel icons famous for their varied menus. (Courtesy Paterson Museum, *Paterson Evening News* Collection.)

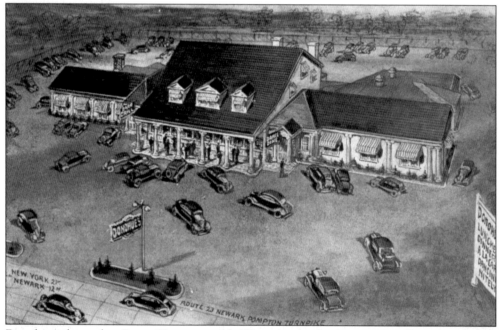

Donohue's, located on Route 23, was possibly Wayne's most famous eatery in the early and mid-20th century. Patrons could be served a hot dog or a full-course dinner. Dancing was available every night. Donohue's was frequented by Babe Ruth, who donated memorabilia, which was displayed behind the bar. (Courtesy Wayne Township Historical Commission.)

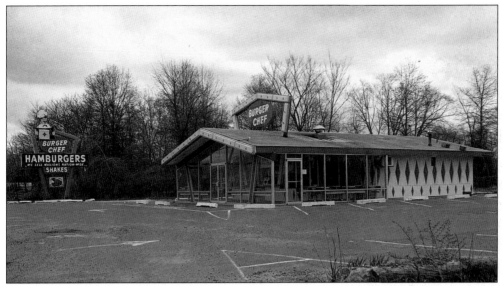

One of the first fast food restaurants in the area was the Burger Chef, built in the 1960s on Route 23. (Courtesy Paterson Museum, *Paterson Evening News* Collection.)

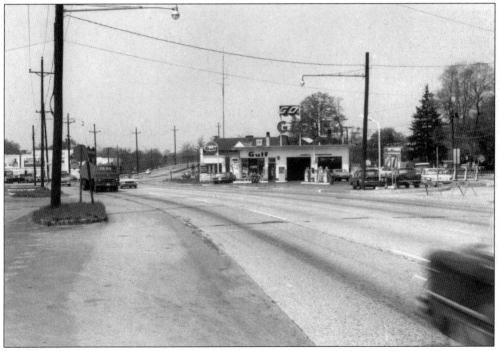

This 1960 view of Route 23 in Mountain View, looking north, shows James Thompson's gas and automobile service station, which sold gas for 27.9¢ a gallon. (Courtesy Wayne Township Historical Commission.)

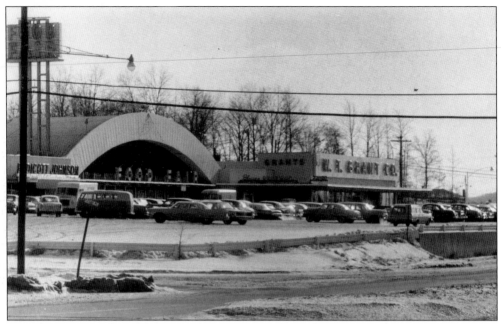

By midcentury, retail establishments began to group themselves in shopping centers called strip malls. This 1960s view of a Route 23 center, adjacent to the Packanack Lake community, offered a supermarket, pharmacy, and variety store. Today, the mall is called the Packanack Shopping Center. (Courtesy Charles Haas.)

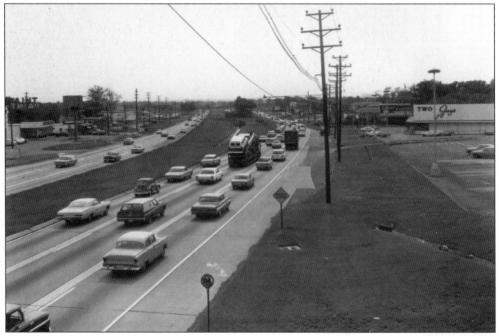

The Wayne highway landscape in 1966 was characterized by high traffic volume, electrical poles and wires, billboards, and the new retail shopping centers, including the Two Guys store, seen here on the right, which is currently a Home Depot. (Courtesy Paterson Museum, *Paterson Evening News* Collection.)

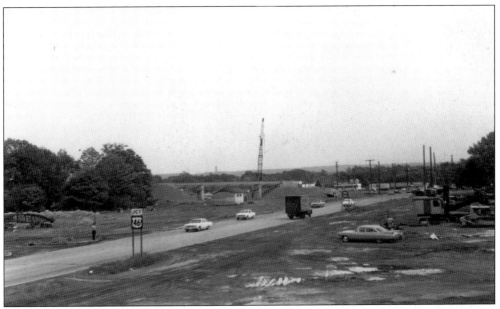

In the mid-1960s, construction of Route 80 and improvement of Route 46 changed the highways into superhighways. The traffic circle at the intersection of Routes 23 and 46 was eliminated. (Courtesy Paterson Museum, *Paterson Evening News* Collection.)

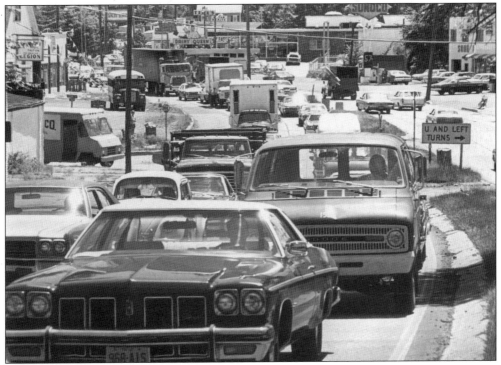

Traffic on the highways of Wayne became congested as rush-hour travel strangled many roadways, as illustrated by this 1970 view of Route 23 in Mountain View. For the next 20 years, highway widening and improvements were required to handle the volume. (Courtesy Paterson Museum, *Paterson Evening News* Collection.)

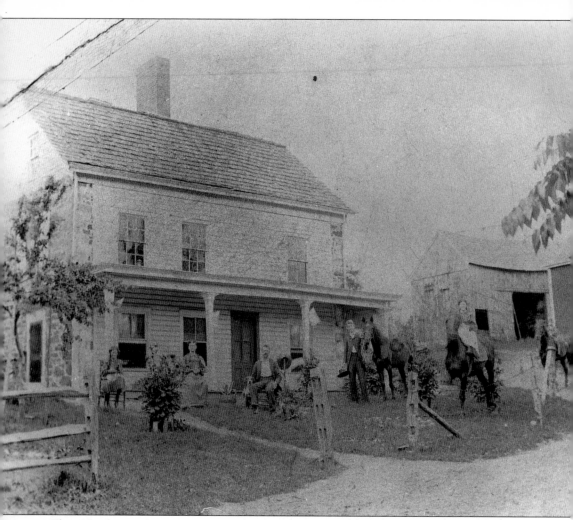

This Hinchman farm scene was photographed in 1896. The farmstead was located on Hinchman Lane at the site of the present-day Ramapo Shopping Center. Primarily a dairy farm, the property was originally purchased by James S. Hinchman in the early 1800s. Hinchman family members are, from left to right, daughter Charlotte, wife Hannah, husband Charles, son John (standing next to horse), daughter Mary (on horse), and son Theodore (on horse). Standing on the far right is Erin Post, brother of Hannah. (Courtesy Wayne Township Historical Commission.)

Four

FARMSTEADS OF THE 19TH CENTURY

The transformation of Wayne Township from a dairy, grain, and vegetable farming economy to a suburban residential community was a tremendous change in 150 years. State of New Jersey statistics for the mid-19th century list the population of Wayne Township at 1,355. Wayne Township is currently home to more than 50,000 residents.

Wayne residents reported ownership of 615 milk cows, 602 cattle, 211 working oxen, 530 swine, and 274 horses in 1860. Farm production included 75,000 pounds of butter and 1,690 pounds of honey. The largest vegetable production was 23,012 bushels of Irish potatoes. Grain production included wheat, rye, oats, buckwheat, and corn totaling over 50,000 bushels as well as 3,136 tons of hay.

In the mid-19th century, Wayne boasted 8,411 acres of improved land; cleared farmland as well as land with architectural structures was considered improved land. If one considers that in 1850, Mead's Basin was then one of the largest groupings of buildings in the township with only 12 buildings, we can surmise that the majority of the more than 8,000 acres was farmland. Since 1995, only one percent, little more than 100 acres of the 26 square miles of land in Wayne Township, is used for agricultural purposes. The latest census reports that fewer than 200 Wayne residents are currently employed in the agricultural industry.

The automobile brought an influx of new residents, forcing the improvement of transportation systems, drinking water and sewage systems, retail shopping, community services, and schools. New technologies—such as the telephone, electricity, and, later in the century, the home computer—freed many people from the cities and attracted them to the Wayne countryside. Many of the amenities of an urban environment were available in Wayne, with the added benefits of a healthful climate and clean air.

The result of this change was the tremendous loss of farmland. Pastureland and cultivated fields became immensely valuable as potential residential lots. Most struggling farmers yielded to the pressures of development and sold portions of their farms. Entire farms were sold when children decided not to follow in the footsteps of their farming ancestors. The lure of the land value became too great.

The images on the following pages illustrate the family farms and agrarian landscape that characterized the Wayne community in the 19th and early 20th centuries.

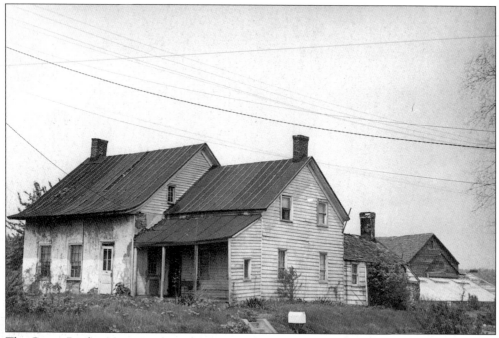

The Garret Berdan Homestead was located on Valley Road in Lower Preakness. Garret Berdan was a descendant of Jacob D. Berdan, who settled in Wayne in 1809. The family dairy farmstead was sold to the Rillo family in the 20th century and eventually demolished in 1972. (Courtesy Wayne Township Historical Commission.)

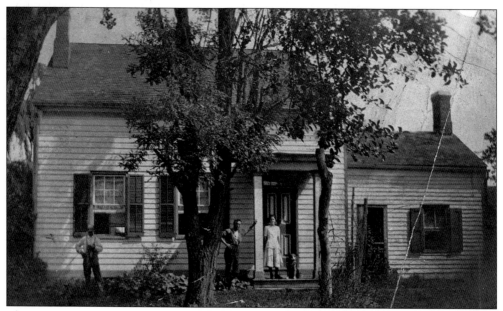

The MacDonald family settled in Wayne in 1905, establishing a truck farm on Valley Road. This view of the MacDonald farmhouse in 1915 shows, from left to right, owner Peter A. MacDonald Sr., his brother Donald MacDonald, and daughter Mae MacDonald Kiviet. (Courtesy Wayne Township Historical Commission.)

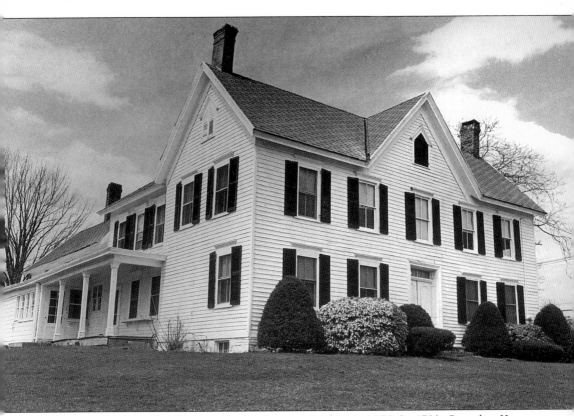

This photograph of the Kip-Blain-Nellis farmhouse was taken in 1978. In 1723, Cornelius Kip and George Doremus purchased 600 acres in Lower Preakness from the heirs of Thomas Hart, one of the East Jersey proprietors. The Kip family operated a farm and two mills on the property. Nicholas Kip, a descendant of Cornelius, built the two-story clapboard farmhouse c. 1840. Isaac W. Blain purchased the farmhouse in 1867. The additions to the home probably occurred during his ownership. Jacob Nellis purchased the property from Blain in 1903, and his family ran the farm until 1957, when Wayne Township purchased the property. The farmhouse became the headquarters of the Wayne branch of the American Red Cross from 1979 until its demolition in 1990. (Courtesy Wayne Township Historical Commission.)

This *c.* 1912 photograph shows a Mrs. Mansius with her dog and grape arbors in the family farmyard. The Mansius farm was located near the current Packanack ball fields. (Courtesy Wayne Township Historical Commission.)

Enjoying a summer afternoon at the recently completed Frederick Mansius house on Cedar Place, these women are quite fashionably dressed in 1917. The house burned to the ground in 1928. (Courtesy Wayne Township Historical Commission.)

This rear view of the Martin house is dated c. 1923. The house originally fronted on Newark-Pompton Turnpike. Now, it is located on the corner of Hobson and Old Turnpike Roads. The property was originally Stagg Farms and later became the Kelly homestead. (Courtesy Wayne Township Historical Commission.)

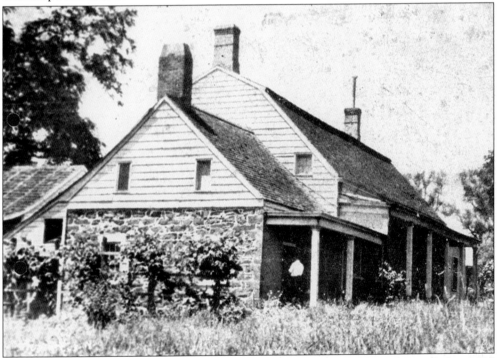

The Lafayette Ryerson House was built c. 1787 on Ryerson Road. It was dismantled in 1935 and reconstructed on Hathaway Lane in Essex Fells by owner Edward R. Candors. (Collection of the author.)

The Schuyler-Graham farm was photographed in 1900. The original farmhouse is documented on an 1862 map but probably dates much earlier, as Isaac Schuyler owned the property in 1825. The Victorian-style addition was completed *c.* 1875. Schuyler operated a stone quarry, store, and docks on the land. His son Phillip sold 110 acres to James Graham between 1866 and 1869. (Courtesy Wayne Township Historical Commission.)

In 1928, James's son Andrew Graham inherited the property. He ran the farm until 1952. The homestead burned in 1980. This photograph shows Andrew Graham Sr. and Jr. in front of the barn located on the Pompton Plains Crossroads near the current Sheffield Post Office. (Courtesy Wayne Township Historical Commission.)

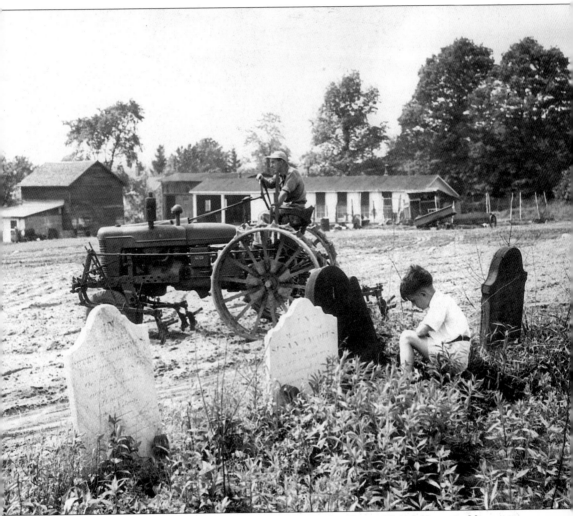

The Tether farm, originally part of the Jacobus property, near Route 23 in Mountain View, was photographed in 1960. The oldest gravestone in the Jacobus-Jones graveyard is dated 1765. (Courtesy *Newark News*.)

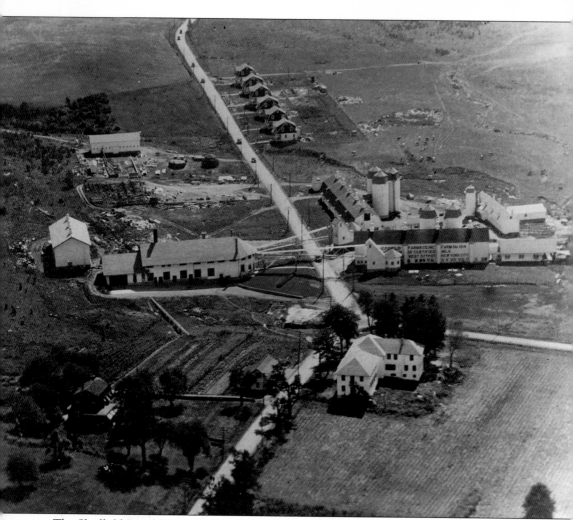

The Sheffield Farms Dairy was founded in 1902 to improve milk distribution to New York City residents. Combing the resources of four dairies, the company planned to improve milk cow herds and the quality of milk, while upholding sanitary conditions. In 1913, they introduced Select milk, requiring farmers to meet higher standards than board of health requirements. In 1926, homogenized and vitamin D-added milk were introduced. Later, certified milk was sold. Cows were TB tested, the barns were sanitized, the stables were whitewashed, milk pails were covered, and all utensils were washed and sterilized. Finally, the machine age brought machine-sealed bottles, replacing the custom of dipping milk from large cans and pouring into containers provided by customers. The aerial view of the Sheffield Farms Dairy is dated c. 1923. The Wayne farm was one of many Sheffield dairies throughout the New York and New Jersey area. Black Oak Ridge Road divides the photograph vertically. Pastures were on the right, as were the milking barns. Milk traveled across the road on an overhead conveyor to be processed and bottled. The houses on the upper right were workers' residences built by the company. (Courtesy Wayne Township Historical Commission.)

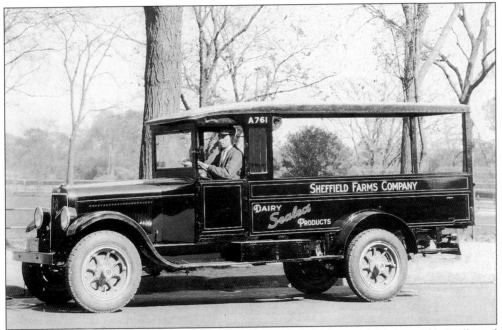

Edward Fullard is shown here in 1931, driving a Sheffield Farms delivery truck. Milk and milk products were delivered to surrounding communities on a daily basis as part of the company's plan to provide fresh, wholesome, and sanitary milk to children every day. (Courtesy Wayne Township Historical Commission.)

The Van Ammers Dairy Farm was located on Route 23, on property now used as a parking lot for the Willowbrook Shopping Center. The original Dutch farmhouse with gambrel roof was altered with roof dormers and a front porch. The trucks were used for daily milk delivery routes. The cow pastures are to the left of the barn. On the extreme left rear is the Wilkie House. Later in the century, the Wilkies built a racetrack and kept trotters. (Courtesy Wayne Township Historical Commission.)

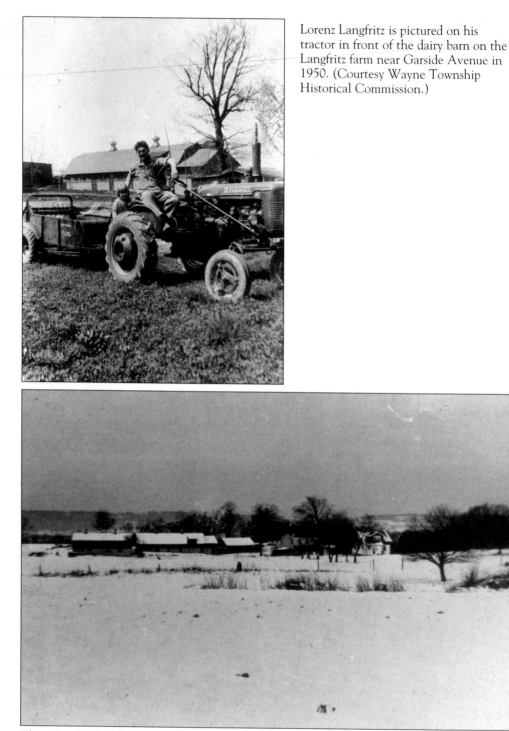

Lorenz Langfritz is pictured on his tractor in front of the dairy barn on the Langfritz farm near Garside Avenue in 1950. (Courtesy Wayne Township Historical Commission.)

This winter scene shows the Langfritz farm in 1948, before the residential development of the property. From left to right are the maternity barn, milking barn (for 36 cows at the time), garage, pasteurizing plant, old farmhouse, and newer residence. (Courtesy Wayne Township Historical Commission.)

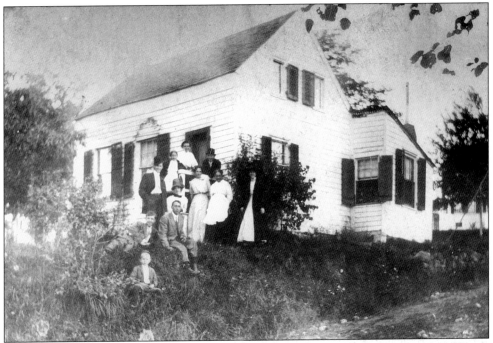

The 150-acre Jacobus farm was located in the Mead's Basin area between Alps Road and Parish Drive. The farmhouse, built c. 1847, is photographed here c. 1890 with the residents, the Thomas Jacobus family. The building was demolished in 1918 for construction of a new home. (Courtesy Wayne Township Historical Commission.)

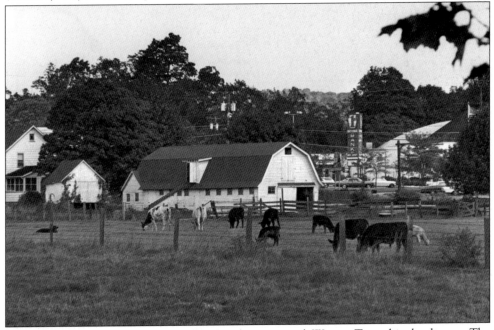

This 1960 dairy farm scene on Valley Road is a typical Wayne Township landscape. The encroaching commercial development is visible in the rear at the right. (Courtesy Paterson Museum, *Paterson Evening News* Collection.)

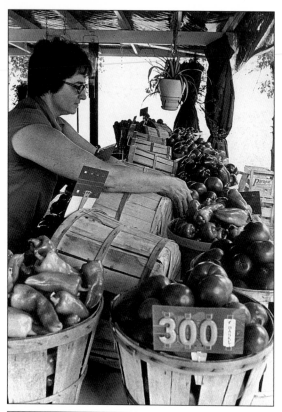

The Keuhm Farm occupies the corner of Black Oak Ridge Road and the Pompton Plains Crossroads. In 1976, the farm operated a roadside vegetable stand, which has recently grown into a retail store in a new barn building. (Courtesy Paterson Museum, *Paterson Evening News* Collection.)

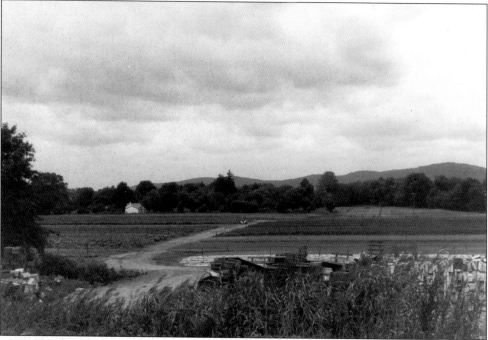

In this 1976 photograph (looking west), the cultivated fields of the Keuhm Farm stretch all the way to the Pompton River. (Courtesy Paterson Museum, *Paterson Evening News* Collection.)

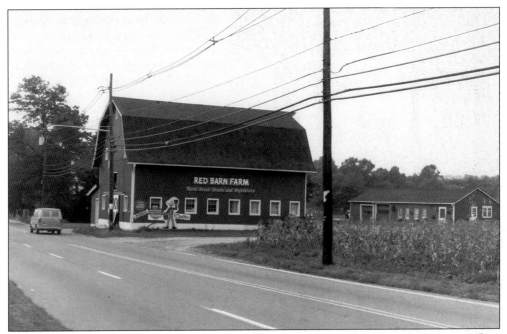

Red Barn Farm, the last remaining farm on Valley Road, was a landmark for many years. When the road was widened to four lanes, the road in front of the red barn remained with only three lanes. The barn would have had to be torn down to add the fourth lane. The farm property was eventually sold for residential development, and the farmhouse and barn were demolished in 1998. Today there is a fourth lane in the location of the old barn. (Courtesy Wayne Township Historical Commission.)

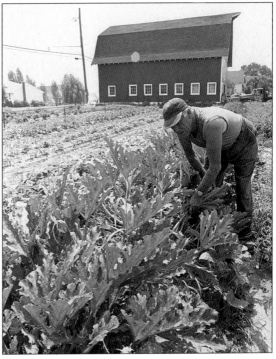

In 1967, this farmer at Red Barn Farm is surrounded by residential development. The farm produced corn, vegetables, strawberries, and squashes, which were sold in the barn retail store. (Courtesy Paterson Museum, *Paterson Evening News* Collection.)

Klein's Grove, near Washington Street in Mountain View, was operated by proprietor Bruno Klein. This 1922 photograph was used to advertise the tranquil and rustic setting of the grove. The grove boasted a swimming lake, quiet trails, a ball field, dancing pavilion, and plenty of parking. (Courtesy Wayne Township Historical Commission.)

Five

THE COURSE
OF WATER

Wayne has always been associated with water. Native Americans traveled the waterways for thousands of years before European settlers arrived. Arent Schuyler remarked upon the beautiful river valley and its potential for transporting products. Dutch settlers harnessed the power of the rivers for gristmills and sawmills and to irrigate their crops. The Morris Canal Pompton feeder was an important transportation development that carried numerous products more economically than by wagon and controlled the water flow from Greenwood Lake into the Pompton River. The rivers provided recreation: swimming, canoeing, and camping, drawing vacationers out of the cities and into the country. The manufactured lakes were formed by dam engineering feats, which controlled the water to create centers for growth of new communities: the Packanack, Pines, and Lions Head lakes. The Point View Reservoir project flooded the Pancake Hollow area, providing water for urban New Jersey communities. Of course, there are also floods; the power of water is always respected in Wayne. The destruction of private property and human life that occurs along the rivers is a way of life for some communities, including Fayetteville, Hoffman Grove, and Mountain View. The beauty and the power of water have shaped this township and will continue despite our efforts to tame it.

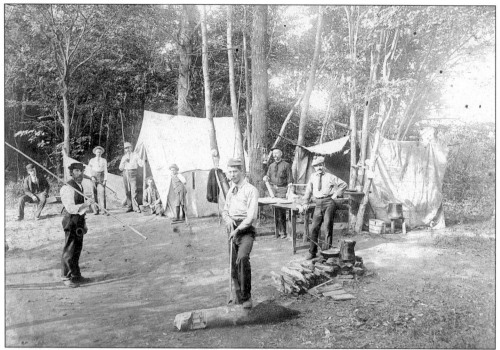

Camping excursions along the rivers were common. This 1912 camp is located on a small island in the Ramapo River. Dr. William Colfax is pictured standing on the left holding a long pole. (Courtesy Wayne Township Historical Commission.)

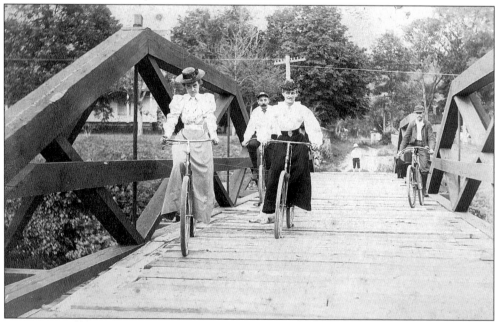

Bicycling along the rivers was a popular way to spend a summer afternoon. This scene on the Colfax Bridge, which spanned the Pompton River, was photographed c. 1910. Local residents Jennie Colfax (left) and Amelia Berry (right) bicycle with full skirts and hats. (Courtesy Wayne Township Historical Commission.)

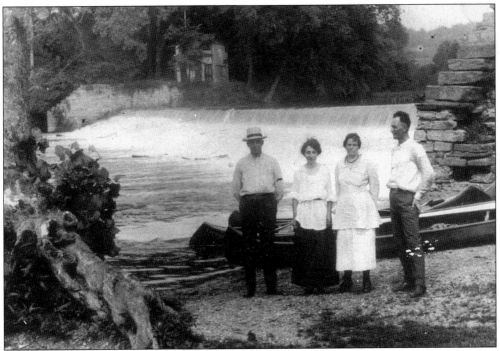

A dam was constructed on the Pompton feeder of the Morris Canal to control the water level in the canal. In this *c.* 1920 photograph, canoeists are enjoying the water at the foot of the dam. (Courtesy Wayne Township Historical Commission.)

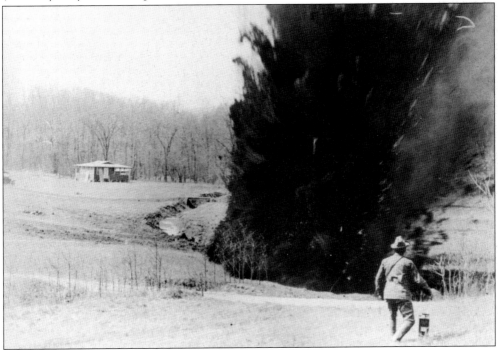

In 1920, an attempt to dig a canal in the Riverview Community from Kievet's Pond to the Pompton River was made using dynamite. (Courtesy Wayne Township Historical Commission.)

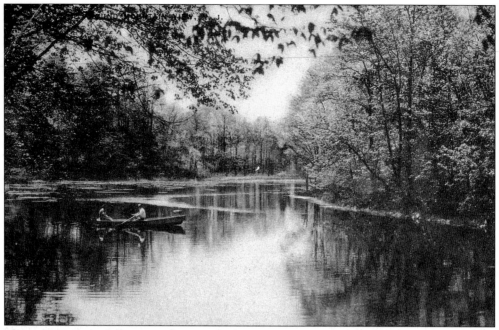

This c. 1920 view of the tranquil Pequannock River encouraged seasonal and weekend visitors, who crowded the rivers with canoes. (Courtesy Wayne Township Historical Commission.)

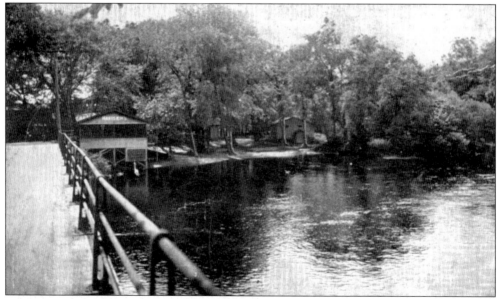

Haviser's Pavilion and Beach, on the Pompton River in Mountain View, were popular weekend destinations for residents and visitors alike. Residents stored their canoes at the boathouse. Swimming, boat rentals, and nighttime dancing were available. (Courtesy Wayne Township Historical Commission.)

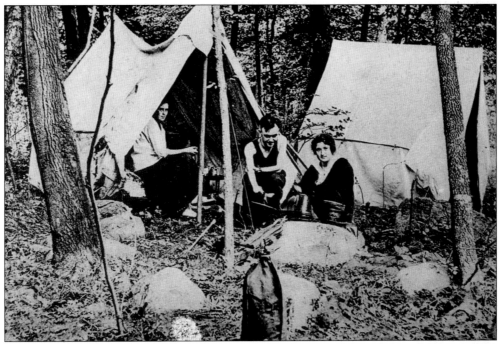

Camping along the banks of the river in Mountain View was a seasonal activity. This c. 1920 postcard image shows a typical weekend campsite. (Courtesy Wayne Township Historical Commission.)

Shown in 1923, the Bungalow Club, located on the Pompton River in Mountain View, was an active summer club providing river sports. (Courtesy Wayne Township Historical Commission.)

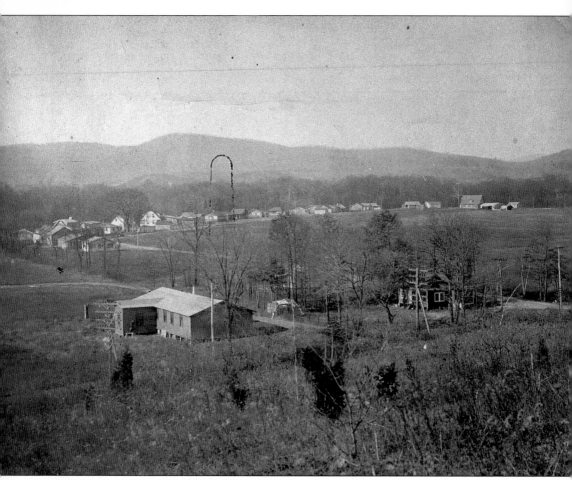

Hugh C. Colville established the Riverview Community. Following a summer camping in a tent with his family on the Pompton River, he began to look for property on which to develop summer homes. The land he chose was originally part of a Ryerson farm. It was bounded by the Kievet Farm on the north, Hamburg Turnpike and Black Oak Ridge Road on the east, the river on the west, and South Road in the south. Photographed in 1922, Riverview had begun to develop. Armstrong's Shop is in foreground at left, and the Tea House (a snack and ice-cream shop) is at right. Vegetable and fruit gardens were planted along the east side of Shore Road in the background. Bungalows were built along the west side. The large building in the right rear is the clubhouse.

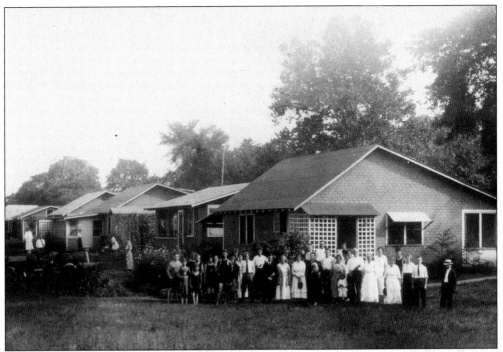

In 1917, Colville purchased 85 acres, constructed a road, and laid out bungalow lots, which he sold. By 1920, a large group of summer residents had erected bungalows in Riverview. (Courtesy Wayne Township Historical Commission.)

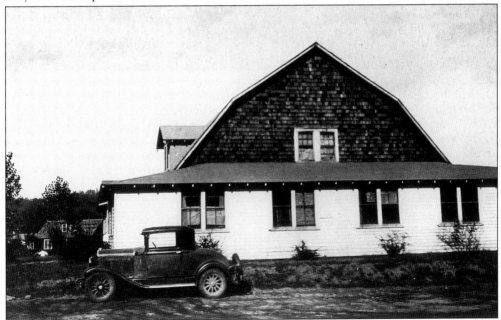

In 1920, an open-air dance platform was built by community volunteers, followed by a clubhouse in 1922. Located on North Road, the Riverview Community Clubhouse's dance floor was famed for its highly polished maple surface. A kitchen, porches, and other necessities were added over the years. (Courtesy Wayne Township Historical Commission.)

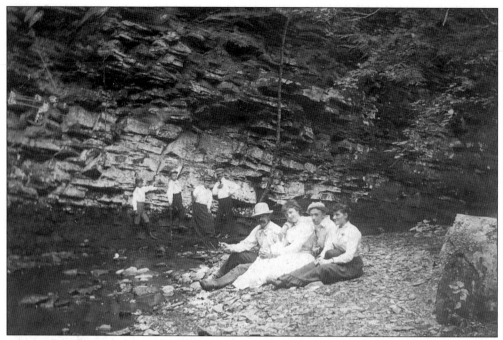

August 16, 1891, was a great day for an excursion to what we now call the Pines Lake glen and gorge. The dammed lake did not exist at this time, but the glen was a cool spot for a summer walk along its meandering brook. (Courtesy Wayne Township Historical Commission.)

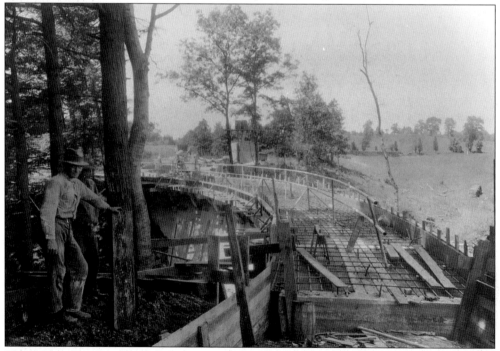

This 1921 view of the Pines Lake dam shows the road surface under construction. The glen is to the left of the dam and, to the right, the unfilled lake bottom is visible. (Courtesy Wayne Township Historical Commission.)

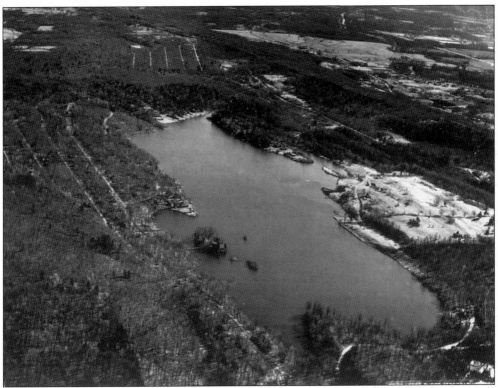

Pines Lakes is approximately a mile long and a half mile wide. This aerial photograph was taken shortly after the lake was filled. Pines Lake advertising in 1927 stated that Pines Lake was "a haven for pleasant people who have the means and the inclination to build a home away from the din and disorder of ordinary places. The purpose and plan is to make this an exclusive colony in which the rights of all property owners are considered and preserved." (Courtesy Wayne Township Historical Commission.)

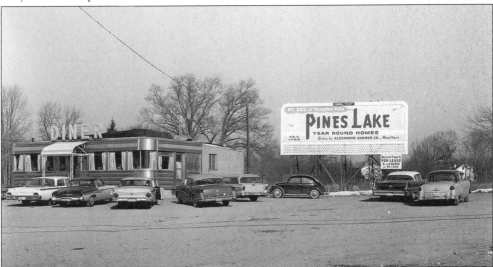

Located on Route 23, this 1962 billboard advertises year-round homes for sale at Pines Lake. (Courtesy Wayne Township Historical Commission.)

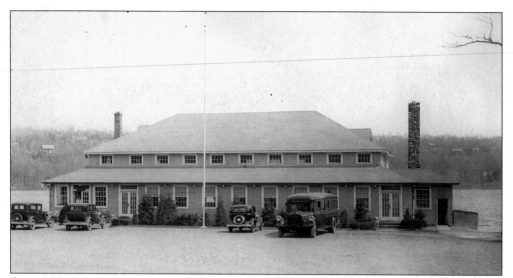

Joseph Castles, his sons, and son-in-law purchased 27 Wayne farms, totaling 700 acres, and created the Irvington Hunting and Fishing Corporation in 1925. Within a year, his dream of creating a model community took shape, and the real estate was transferred to Packanack Lake Inc. The one-half-mile-long dam was constructed, the lake area was cleared, roads were cut, and other community services were established. On May 6, 1928, the clubhouse and 17 other log cabins and houses were under construction as Castles held an opening day. Initial home sales totaled over $400,000. Beach sand was brought from the New Jersey shore, fish were stocked in the lake, and tennis courts, a bathhouse, and polo grounds were built. Free bus service to commuter trains was provided. Social events and activities brought families and neighbors together. This photograph of the Packanack Clubhouse was taken shortly after its construction. (Courtesy Charles Haas.)

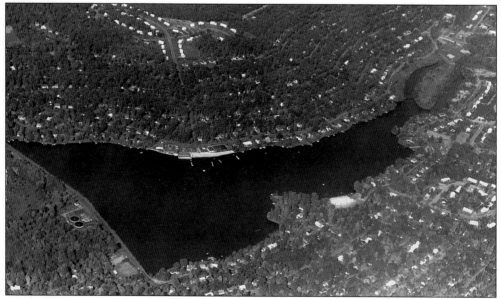

This c. 1960 aerial photograph of Packanack Lake shows the dam along the left side of the lake. Residential developments ring the lake. The club's original 600 members have grown to 1,450 members and 1,600 homes in 50 years. (Courtesy Charles Haas.)

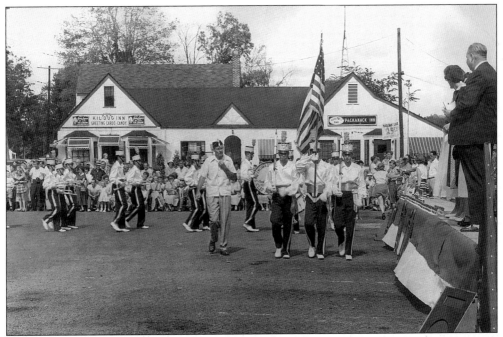

Packanack Lake's 25th anniversary in 1953 is celebrated with a parade past the reviewing stand in front of the clubhouse. The Packanack Inn is shown in the background. (Courtesy Charles Haas.)

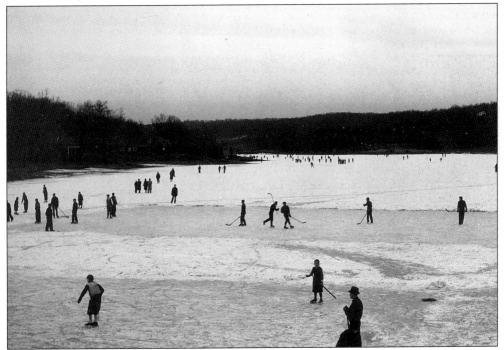

January 1939 brought cold weather to Wayne and a resulting frozen Packanack Lake. Skating and hockey enthusiasts took advantage of the opportunity to enjoy the ice. (Courtesy Charles Haas.)

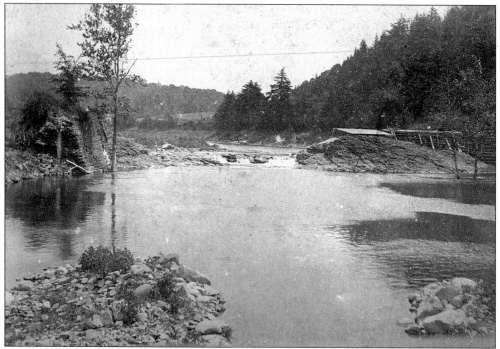

This view of the devastating flood of 1903 looks east at the foot of the current Pompton Falls. The dam constructed here failed, and water traveled downstream, destroying the Ludlum Steel Works and many other buildings. (Courtesy Wayne Township Historical Commission.)

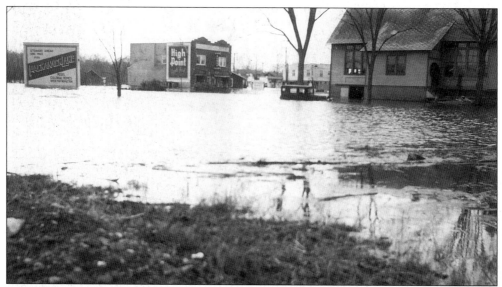

This 1936 photograph of Mountain View center was taken during the flood. The municipal building is on the right. Note the partially submerged car in the parking lot. Ninety-eight men, women, and children were evacuated and housed in the Mountain View School for almost three weeks. (Courtesy Wayne Township Historical Commission.)

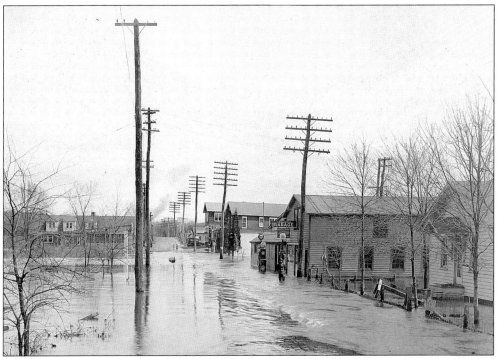

The streets of Mountain View were impassable by car following the 1936 flood. Here, a resident wades through knee-deep water. (Courtesy Wayne Township Historical Commission.)

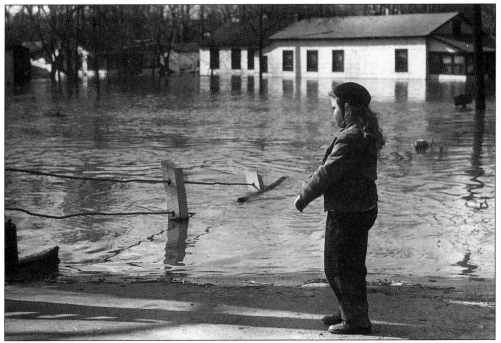

The intersection of Fairfield and Fayette Roads in Mountain View was flooded again in 1942. Residents were aided by the Wayne branch of the American Red Cross with food, clothing, and shelter. (Courtesy Wayne Township Historical Commission.)

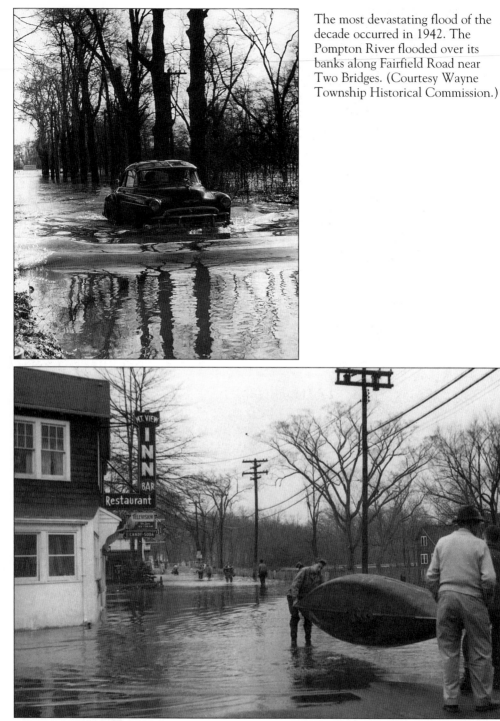

The most devastating flood of the decade occurred in 1942. The Pompton River flooded over its banks along Fairfield Road near Two Bridges. (Courtesy Wayne Township Historical Commission.)

This photograph was taken on April 1, 1951, in Mountain View. Boonton Road in front of the Mountain View Inn was flooded. Residents took to their canoes, usually reserved for river recreation, in order to return home and inspect the damage. (Courtesy Wayne Township Historical Commission.)

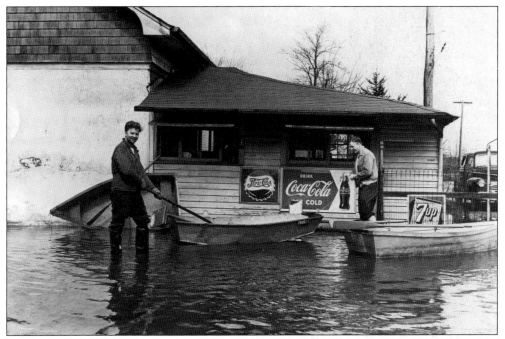

The spring flood of 1951 damaged or destroyed a large part of the property west of Mountain View and Route 23. This luncheonette close to Ryerson Avenue was flooded. (Courtesy Wayne Township Historical Commission.)

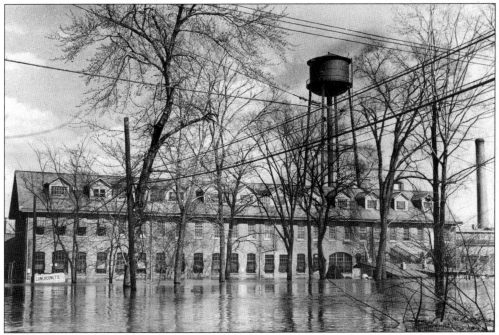

The Wayne Mack-Moulding Company, on the site of the former Laflin and Rand Company Powder Works, suffered water damage during the 1951 flood. Located on Ryerson Avenue, the entire low-lying area adjacent to the Pompton River was covered by the rising water levels. (Courtesy Wayne Township Historical Commission.)

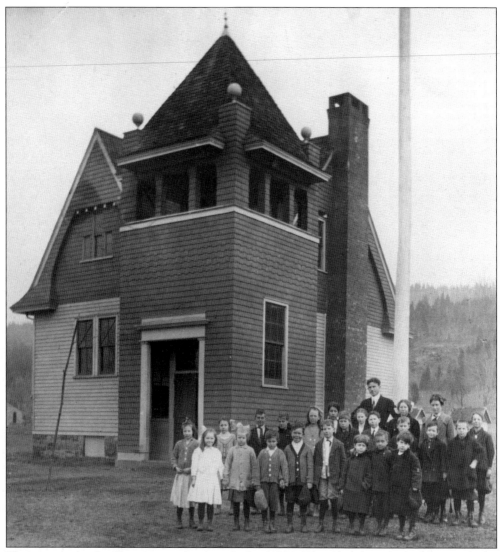

This two-story schoolhouse was photographed c. 1900. The Shingle-style building with the large bell tower and sloping rooflines was built in the last decade of the 19th century. School No. 16 was located near the corner of Black Oak Ridge Road and Newark Pompton Turnpike. Called the Pequannock School, it was renumbered in 1894 to become School No. 4. (Courtesy Wayne Township Historical Commission.)

Six

THE SEARCH FOR KNOWLEDGE

The earliest record of a school building in Wayne was found in a deed reference dated 1743, describing the property outline as 31 links from the northwest corner of the old stone schoolhouse. As recorded in an 1812 deed, the Franklin School Association purchased a plot of land and erected a one-room school in Mead's Basin. A two-room school replaced the one-room schoolhouse on the site *c.* 1890. That building, later used as the township municipal building, is currently in use as the American Legion Building.

Local lore says that Wayne's first school was housed in a dugout. A dugout was carved from the hillside. A wooden roof covered the extended portion of the structure and a stone wall facade opened with one heavy wooden door. Gen. Anthony Wayne is said to have stabled his soldier's horses in the dugout during his residence in Wayne in 1780.

By the late 19th century, there were five elementary schools in Wayne, each governed by a separate school board: School No. 13, Mountain View School on the Newark-Pompton Turnpike; No. 14, Upper Preakness School on Hamburg Turnpike; No. 15, Lower Preakness School on Valley Road; No. 16, Pequanock School near the intersection of Black Oak Ridge Road and the Newark-Pompton Turnpike; and No. 17, on the east side of Hamburg Turnpike behind the Norton House Inn. High school students commuted to other area schools.

A state law in 1894 required one school board to administer all schools in a municipality. The schools were renumbered: No. 13 became No. 1; No. 14 became No. 2; No. 15 became No. 3; No. 16 became No. 4; and No. 17 became No. 5. A new school on Ratzer Road became No. 6. At one of the first recorded board of education meetings held in Wayne in 1894, school texts were selected for all students. These included a speller; grammar, history, geography, and arithmetic books; *Webster's Dictionary*; and books on bookkeeping and penmanship.

In the 21st century, Wayne has nine elementary schools, two middle schools, and two senior high schools with an enrollment of more than 6,800 students.

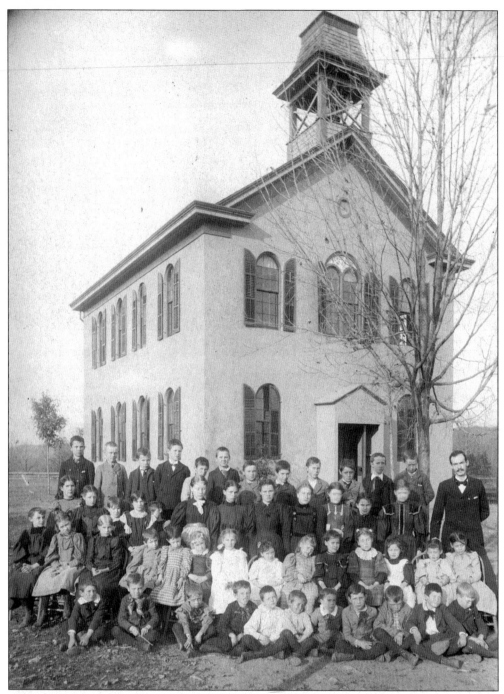

This scene of the school class of the Upper Preakness School, then No. 14, was taken c. 1890. The two-story school building was constructed shortly before 1880. Initially, one instructional room was used on the first floor. The second floor was used for school activities, plays, and programs but was later converted to a classroom. (Courtesy Wayne Township Historical Commission.)

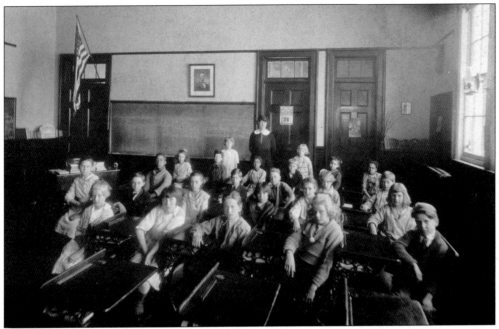

This interior view of the classroom was taken *c.* 1910. Note the photograph of Abraham Lincoln on the wall. The door calendar behind the teacher reads, "Friday, March 24." One of the school desks was preserved and is on display at the Van Riper-Hopper Historic House Museum in the children's room. (Courtesy Wayne Township Historical Commission.)

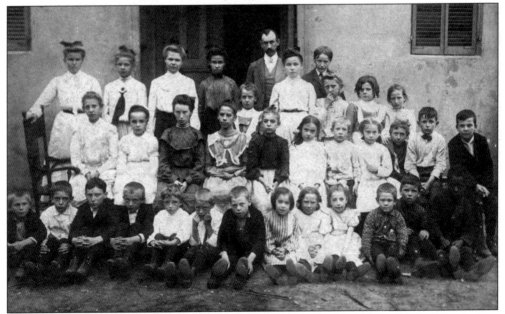

The class photograph was taken *c.* 1900 in front of the Upper Preakness School. The schoolmaster stands in the back row center. An 1848 Wayne school report states that all teachers were male and in their twenties. One teacher had six years of experience, the others had less. The first documentation of a female teacher in the Wayne system occurred in 1900. (Courtesy Wayne Township Historical Commission.)

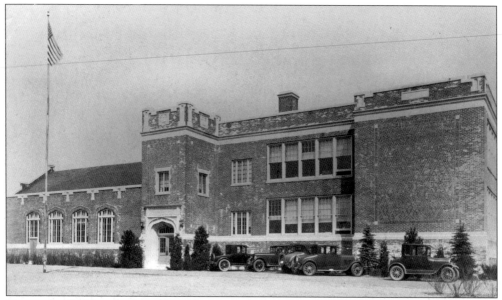

It was decided by the board of education to consolidate schools in 1920. A large brick elementary school was planned to replace the Upper Preakness School on Hamburg Turnpike. Architect Fred Wesley Wentworth designed the new school that was opened in 1923. The pupils from the Upper Preakness School, Valley Road School, Pompton Falls School, and the Ratzer Road School were reassigned to it. This photograph was taken in 1928. (Courtesy Wayne Township Historical Commission.)

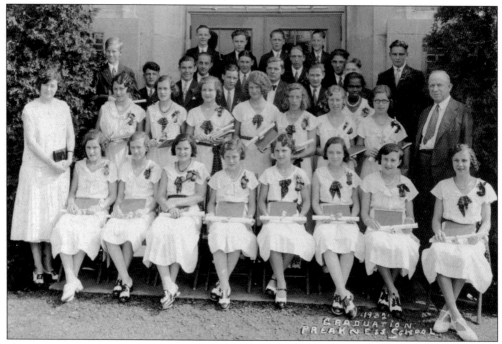

Shown in front of the new Preakness School, the eighth-grade graduating class of 1932 poses with their diplomas. Note the fashionable spectator shoes, bobbed haircuts, and finger waves that were popular with women at the time. (Courtesy Wayne Township Historical Commission.)

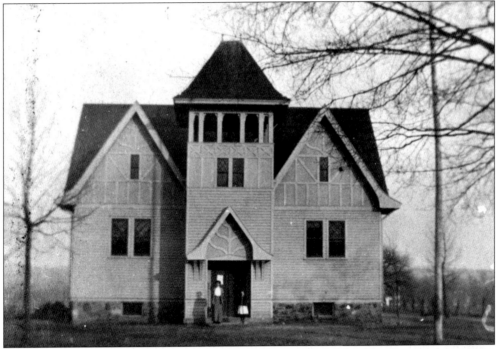

The Lower Preakness School No. 15 was photographed in 1915. The school served the children from the Valley farm area. The doors were closed in 1923, when students were assigned to the new Preakness School. (Courtesy Wayne Township Historical Commission.)

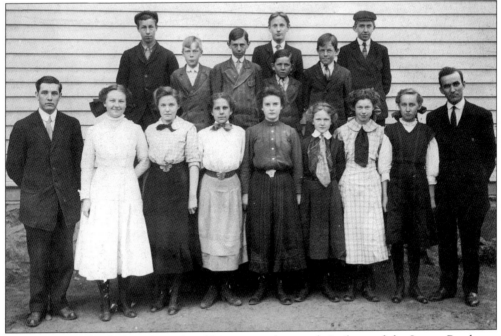

This c. 1900 school class, dressed in Victorian style, stands in front of the Lower Preakness School. Note how the girls are wearing "high button" shoes. (Courtesy Wayne Township Historical Commission.)

A one-room schoolhouse was erected on this site sometime after 1815. In 1890, a two-room schoolhouse replaced the original. This building housed the Mountain View School until 1920. After 1920, the Township of Wayne used the old schoolhouse for a municipal building. It remained in use until the new municipal complex was constructed on Valley Road in 1959. Currently, the Anthony Wayne Post of the American Legion uses the building. This image was taken in 1949, when the building housed the municipal offices. (Courtesy Wayne Township Historical Commission.)

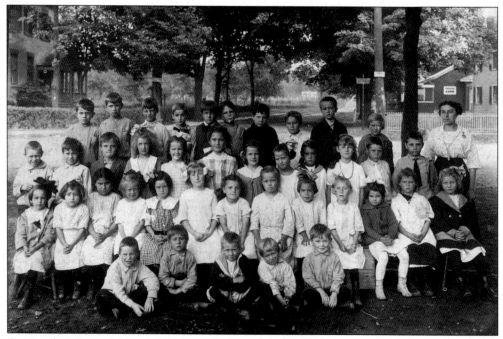

On October 13, 1914, the children of the Mountain View School pose in a picture taken in front of the school on the Newark-Pompton Turnpike. The Mead House, destroyed by fire in 1918, can be seen in the rear left. (Courtesy Wayne Township Historical Commission.)

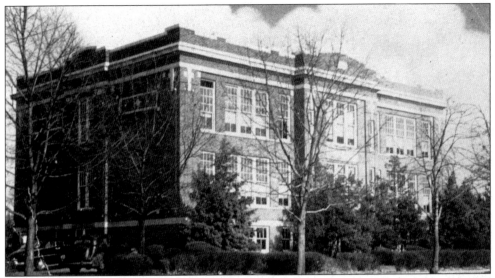

Built in 1920, the new Mountain View School No. 1 was constructed on the site of the old Mead House. Part of a plan for civic improvements and quality education, the three-story brick school dominated the street line of the small community. (Courtesy Wayne Township Historical Commission.)

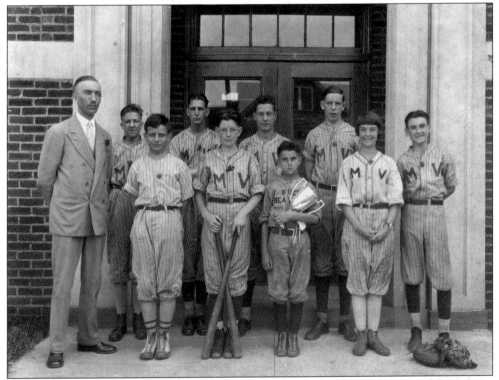

The Mountain View School baseball team, photographed in front of the school, included a female member in 1927. From left to right are Rupert Bellis, George Van Riper, Mickey Nelsen, Orval Champie, Ralf Boob, Norman Hoffman, John DeLap, John Mitton, Elise Forsburg, and Eddie Leonhard.

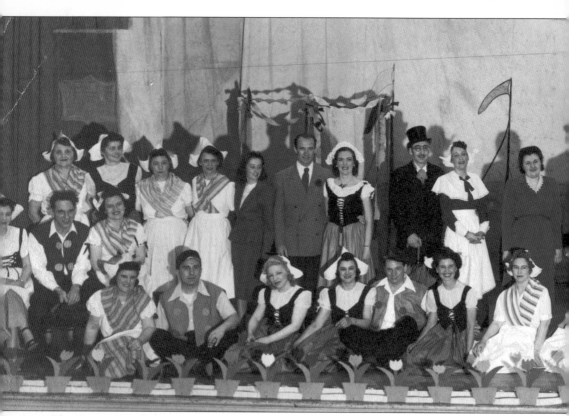

The Parent-Teacher Association of Wayne presented a two-act musical in the junior high school auditorium on May 14 and 15, 1948, for the benefit of Chilton Memorial Hospital. Plays

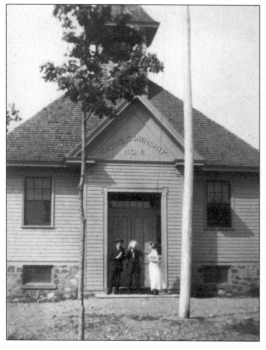

Ratzer Road School No. 6 was added to the Wayne school system in 1894. A quarry behind the school was an attraction for after-school hiking. (Courtesy Wayne Township Historical Commission.)

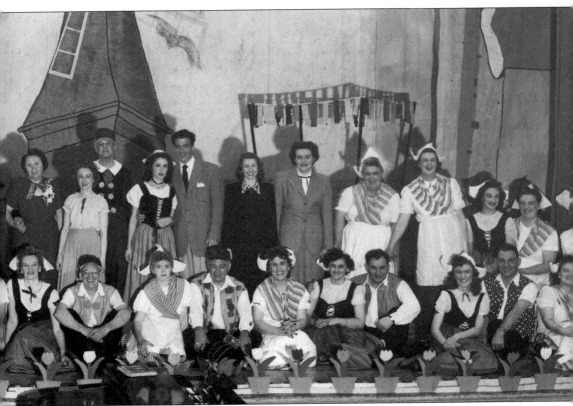

and musicals that referenced the Dutch heritage of the community were frequently staged in Wayne Township. (Courtesy Wayne Township Historical Commission.)

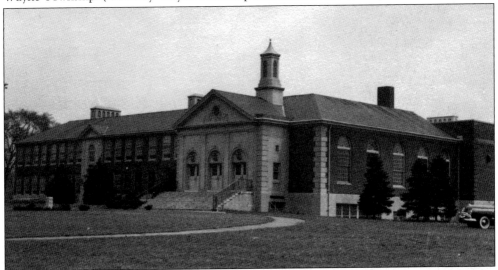

The Anthony Wayne Junior High School was completed in 1937 on Valley Road. Students in grades six through nine were assigned to the school. The school building was sold after the George Washington Middle School, in the Packanack Lake area, and Schuyler Colfax Middle School, on Hamburg Turnpike, were constructed. The property has been converted to a senior center called Sienna Village. (Courtesy Wayne Township Historical Commission.)

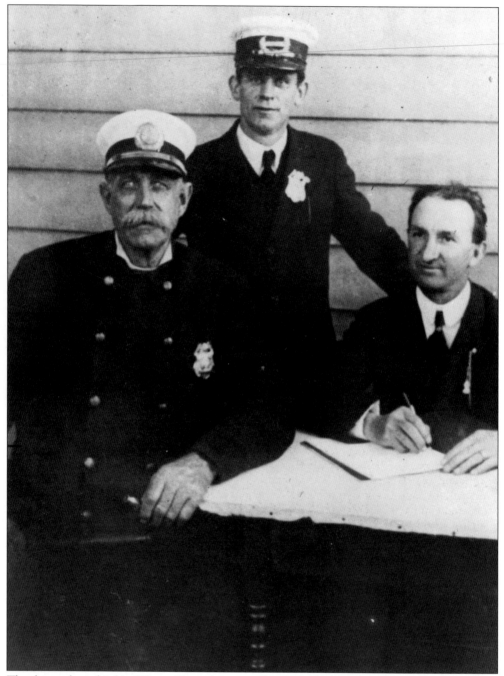

The first police chief in Wayne Township was Chief Charles McGee. Before the date of this 1915 photograph, Chief McGee was the only member of the police force. He rode to work each day on his bicycle. Charles Hamilton became the first police officer at that time. They are both pictured here—Chief McGee on the left and Officer Hamilton in the center. The first police recorder, Harry Hammond, is on the right. (Courtesy Wayne Township Historical Commission.)

Seven

SERVING THE COMMUNITY

The overall size, geography, and individual communities in Wayne Township made the provisions for community services difficult to establish. The agrarian landscape that comprised the township, with the population spread thinly over large areas, made police and fire protection and first-aid services difficult to provide in the 19th century. Community water supply and sewage systems were not established until the 20th century. With the advent of technology—such as the motor vehicle, electricity, and the telephone—remote areas could be serviced as well as the close-knit communities. Until then, much was left to individual neighborhoods to manage.

The Mountain View community was active in organizing efforts to provide its citizens with police and fire protection. The first police chief in Mountain View, Charles McGee, was appointed in 1900. By 1932, Wayne employed nine policemen to patrol 59 miles of roads. First policeman Charles Hamilton had become the chief of police. The most prevalent crimes at the time in the farming community were chicken stealing, produce theft, trespassing, drunk driving by weekend visitors, and parking violations.

A small fire cart was proven ineffective when faced with the devastating fire at the historic Mead House on Newark-Pompton Turnpike in 1918. The community banded together to raise funds for modern fire equipment and the building of a firehouse. The establishment of a volunteer fire department led to the formation of four additional fire companies in Wayne.

The Wayne First Aid Squad was formed in 1943 following a series of local tragedies. Police captain and squad president William Taylor provided land for the first squad building on Oak Street. The squad was housed in the municipal building in Mountain View in 1950, a headquarters building near Parish Drive in 1952, and finally a second headquarters on Hamburg Turnpike in 1956.

The American Red Cross chapter in Wayne Township was active in providing community services, particularly during the periods of flooding in the community. In 1979, the American Red Cross chapter moved into the historic Kip-Blain-Nellis farmhouse on Valley Road.

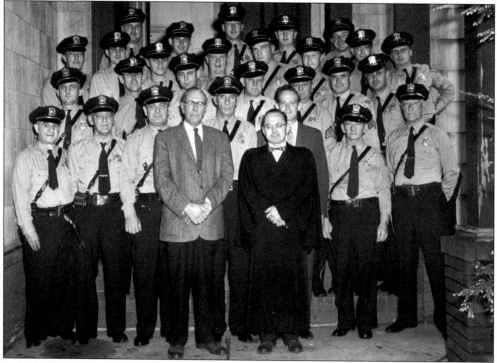

In May 1957, the members of the Wayne Township Police Department, then 26 members strong, were photographed with the township judge (front row, in robe). (Courtesy Wayne Township Historical Commission.)

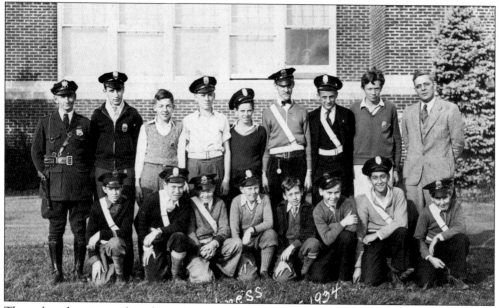

The police department has always been active in youth programs. The Wayne Police Athletic League was founded by Capt. Peter Uberto in 1956. In this 1934 photograph, the youth crossing guards from Preakness elementary school pose with one of Wayne's finest, Off. William Taylor (at left). (Courtesy Wayne Township Historical Commission.)

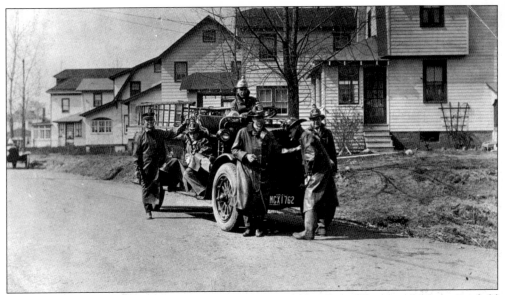

In 1924, the Property Owner's League Fire Company No. 2 was photographed on Fairfield Road. The wood-frame clapboard houses in the background are typical of the architecture in the Mountain View community at the time. Their wooden construction—similar to that of the Mead House, which burned to the ground in 1918—was cause for concern. (Courtesy Wayne Township Historical Commission.)

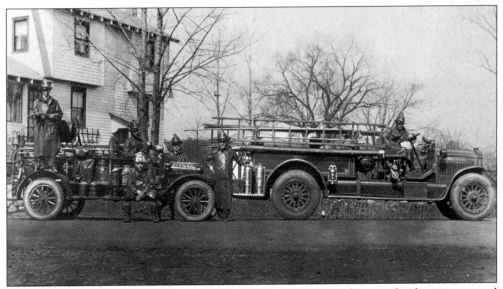

The establishment of the new fire company prompted this 1924 photograph of equipment and volunteer members. Firefighters at the time were threatened by dangers other than fire. Volunteer firefighter Peter Van Ammers was killed on February 2, 1924, when a fire truck he was riding in was overturned while speeding to a fire. (Courtesy Wayne Township Historical Commission.)

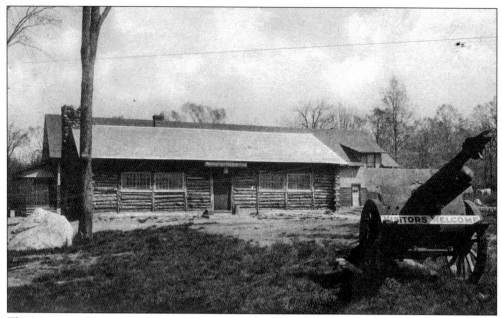

The Mountain View Community Club, built and photographed in 1920, was the first firehouse in Wayne. Following the Mead House fire, neighbors formed a volunteer fire company and built the firehouse with donations and money from fundraising events. The log cabin was built from logs donated by Joseph McDevitt on land donated by local resident and philanthropist LeGrand Parish. Many local organizations held their meetings in the club, including the Masonic Club and the American Legion. Weekly dances were held as fundraisers. (Courtesy Wayne Township Historical Commission.)

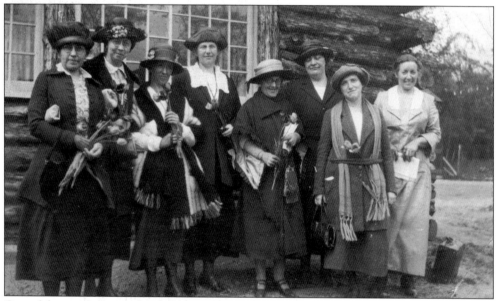

One of the organizations that held meetings at the community club was the County Extension Service. Members are pictured in front of the club in 1922. On the far right are Mrs. W. Brubaker (County Nutrition Leader) and her daughter Mrs. Phillip Lund. (Courtesy Wayne Township Historical Commission.)

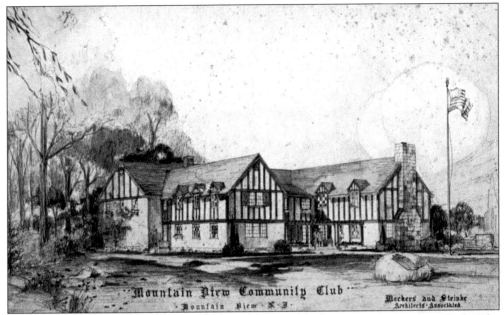

The new log cabin firehouse and community club burned a few years after it was built. The building was a complete loss, as was the fire equipment. The newly designed community club was built in 1930. The club continued to sponsor dances and community activities, until it again burned in 1935. The club was never rebuilt. (Courtesy Wayne Township Historical Commission.)

Weekend dances at the community club were large fundraisers for the fire company. This advertising handbill notes the Meadowbrook Syncopators. Famous local orchestra leader Frank Dailey played at the club until he built the Meadowbrook on Route 23 in Cedar Grove.

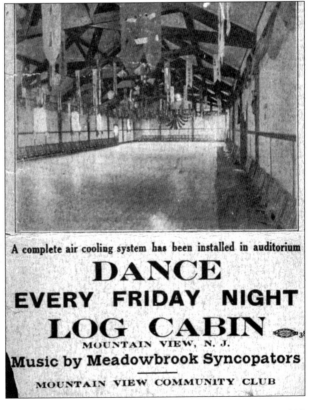

A complete air cooling system has been installed in auditorium

DANCE
EVERY FRIDAY NIGHT
LOG CABIN
MOUNTAIN VIEW, N. J.
Music by Meadowbrook Syncopators

MOUNTAIN VIEW COMMUNITY CLUB

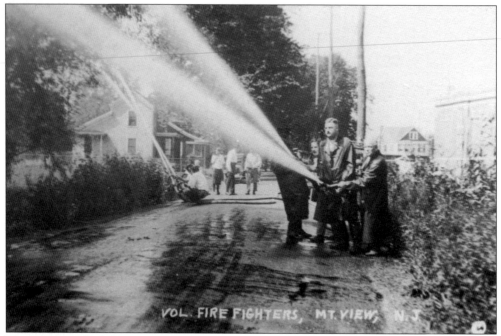

The volunteer firefighters practice with hoses *c.* 1925 on Parish Drive in Mountain View. Amos Mumford is holding the hose. The Mountain View School is seen at the far right. (Courtesy Wayne Township Historical Commission.)

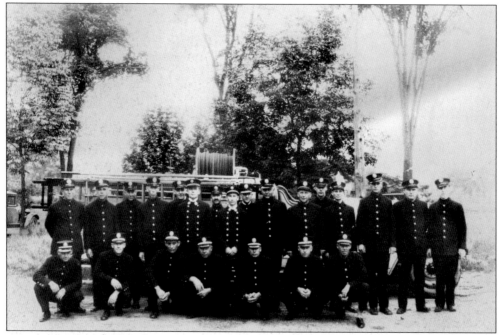

Pictured *c.* 1920 are members of the Community Fire Company No. 1. In the back row on the left is Harry Hosier, owner of the Hosier Brickyard. Fifth from the right in the back row is Edwin Shackleton, owner of the confectionery store across from the Hixon Hotel on the Newark-Pompton Turnpike. (Courtesy Wayne Township Historical Commission.)

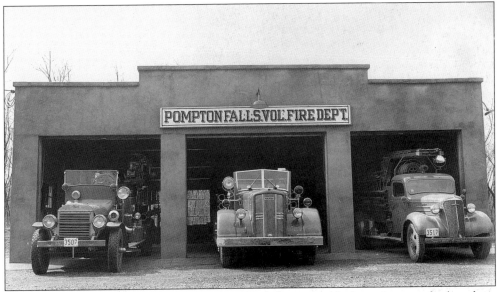

The Pompton Falls Volunteer Fire Company No. 3, located on Jackson Avenue, displays three pieces of equipment in 1950. (Courtesy Wayne Township Historical Commission.)

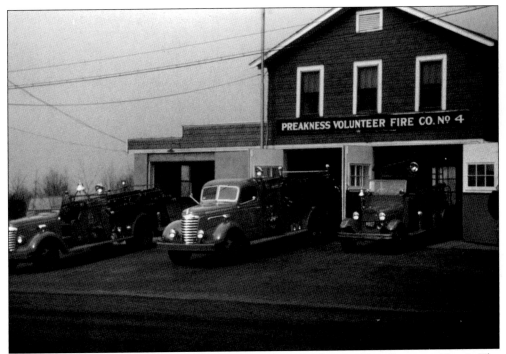

Three fire trucks were in use in 1948 at the Preakness Volunteer Fire Company No. 4. The original firehouse building on Ratzer Road was expanded to provide a garage for the newest equipment. (Courtesy Wayne Township Historical Commission.)

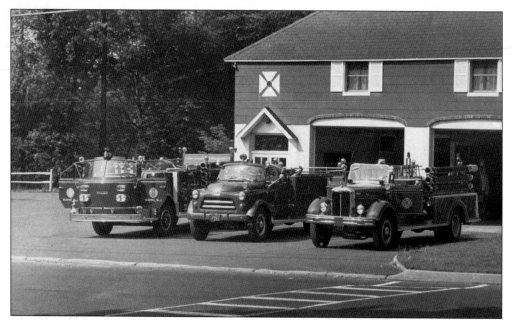

The Packanack Lake Volunteer Fire Company was organized as a World War II Civil Defense Unit. In 1943, it became Company No. 5. The organization was originally housed in a garage at the rear of the post office. It later moved to space in converted bathhouses and then moved to its current location on Lake Drive West. The firehouse was built by the firefighters themselves with volunteer assistance in 1947. In 1978, Walter Jasinski, a member of the Packanack Fire Company since 1948 and past chief, became the first active firefighter in Wayne to be elected mayor. (Courtesy Wayne Township Historical Commission.)

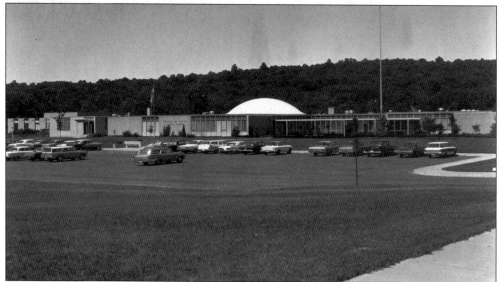

The Wayne Township Municipal Complex was completed in 1959. The complex houses municipal offices, the police department, the health department, and the public library. Its modern design, with central dome over the council chambers and circular floor plan, was considered an important contribution to Wayne's civic architecture. (Courtesy Wayne Historic House Museums.)

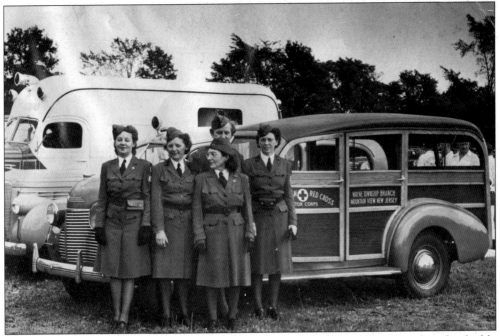

The Wayne branch of the American Red Cross, organized in 1936, has contributed valuable relief services to the community. The members seen in this 1952 photograph are, from left to right, Irene Coolidge, J. Johnson, Alvina Souza (in rear), Emma Newton (in front), and Irene Braks (on right). Behind them is the Wayne Township Memorial First Aid Ambulance. (Courtesy Wayne Township Historical Society.)

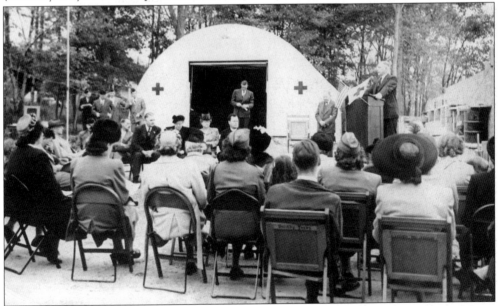

The headquarters for the office, storage facility, and garage of the Wayne American Red Cross branch was located in Mountain View. The Quonset hut was erected following World War II and served for almost 50 years. This scene took place at its dedication. (Courtesy Wayne Township Historical Commission.)

LeGrand Parish, a large man at six feet, was recognized by Wayne residents not for his many patents and inventions (of which there were many) but for philanthropy. Parish held numerous railroad patents, including steam circulation and lining systems for fireboxes, a unique air-brake coupling device, and a railroad car door latch. The result of these successful inventions was disposable money with which LeGrand Parish aided his community. He donated land for the community club and firehouse, a ball field in Mountain View (now called the Parish Oval), and the Passaic County Golf Course. During the Great Depression, his secretary reported that all of the produce from his dairy and vegetable farms was donated to feed the hungry. He was also reported to have assisted his less fortunate neighbors out of their financial troubles. (Courtesy Wayne Township Historical Commission.)

Eight
TWENTIETH-CENTURY HEROES

Heroes of the 20th century in Wayne came in many forms: the famous and successful, the inventive, the generous, the creative, the humorous, human or animal, both young and old and even voices without faces. They have inspired individuals to reach for greater heights, to do the impossible, to try harder, to be better tomorrow than today, to listen, and to care. Residents thank these "doers of great deeds" and inspirers of the human spirit. Heroes are all around us. Each member of the community knows many heroes. Presented here are just a few who have touched lives in Wayne Township in the past century.

LeGrand Parish is pictured at the Lima Locomotive Works in Lima, Ohio, in 1910. Many of Parish's inventions were patented while he was employed at the factory. He eventually became the president of the company. Parish had plans to build and establish a utopian community of thinkers and inventors in Wayne Township. His untimely death occurred before the plans were implemented. (Courtesy Wayne Township Historical Commission.)

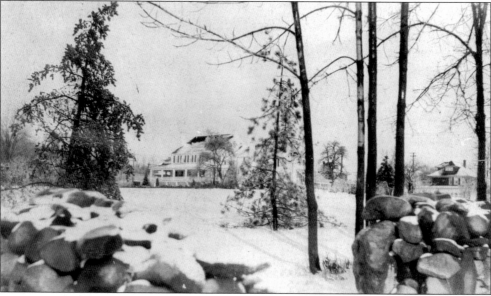

Parish and his wife, the former Madge Little of Mountain View, moved to the area in 1914. They purchased large parcels of land, accumulating more than 45 acres and the historic farmhouse of Jacob K. Mead, which was built by 1780. The Parishes added an extensive wing to their home, designed by architect Fred Wesley Wentworth in 1927. (Courtesy Wayne Township Historical Commission.)

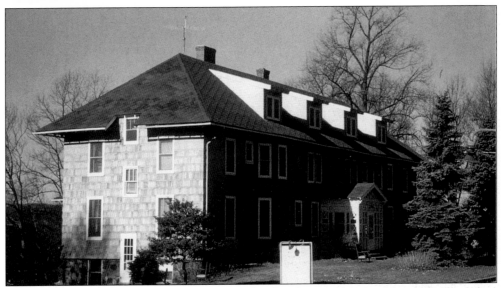

Cecile B. DeMille came to Wayne with his family when he was 10 years old in 1891. His father, Henry, a successful playwright, purchased 76 acres on a hill above Pompton Lake. Pamlico, the DeMille estate house, was a wood-frame, three-story house with wide porches. The early death of Henry DeMille from typhoid in 1893 left his widow with three young children. Mrs. DeMille, a schoolteacher before her marriage, erected a school building (pictured) across the road from the estate. In April 1894, the Henry DeMille Preparatory Boarding and Day School was opened. (Collection of the author.)

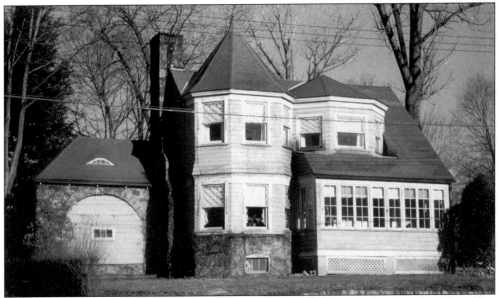

The only remaining vestige of the Pamlico estate and school is the gatehouse. The school building became the Pompton Lakes Nursing Home and was eventually demolished. The estate house was dismantled and the land sold for residential development. Cecile B. DeMille finally left Wayne in 1902. His career in Hollywood as director of such great movies as *The Ten Commandments*, *The Greatest Show on Earth*, and *Reap the Wild Wind* was yet to be realized. (Courtesy Wayne Township Historical Commission.)

Albert Payson Terhune was born in 1872, the child of a minister and an author. Albert's father taught him discipline and religion. His mother, using the pen name Marion Harland, wrote 25 books, inspiring the young Albert to literary pursuits. Educated at Columbia University in New York, Terhune became a staff writer at the *New York Evening World*. His assignments took him all over the world. Terhune wrote more than 60 novels, serials, short stories, and poems. Living at Sunnybank, he befriended the DeMille brothers, his neighbors at Pamlico, after the death of their father. He wrote numerous motion picture screenplays and assorted plays for the theater. His best-known work, *Lad, a dog,* brought him fame and fortune. Stories of Lad, Bruce, Bobby, Treve, and the numerous other dogs who inhabited Sunnybank were cherished by readers worldwide. Terhune was also a breeder of prize-winning champion collies. (Courtesy Wayne Township Historical Commission.)

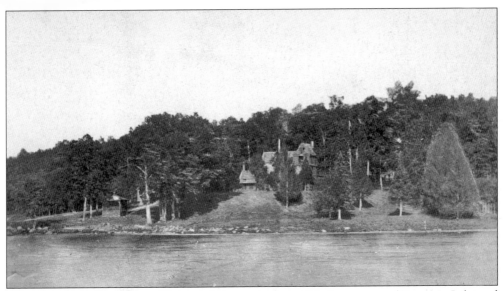

The parents of Albert Payson Terhune first saw the beautiful clear waters of Pompton Lake and the verdant rolling hillsides on the Wayne side of the lake in 1860. Purchased as a summer retreat, Sunnybank was soon filled with many varieties of plants, which Terhune's mother brought back from her extensive world travels, creating beautiful natural gardens with unusual plantings. The wisteria vine, which wrapped itself around the entire house in later years, draped the house in purple during the spring. (Courtesy Wayne Township Historical Commission.)

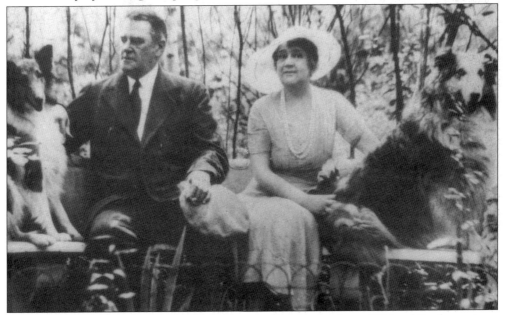

Terhune wed Anice Stockton in 1901. Anice was a direct descendant of Richard Stockton, signer of the Declaration of Independence and owner of the Stockton family estate Morven, donated to New Jersey for a governor's mansion. Anice was a composer of more than 100 songs and lyrics, many of them for children. Trained at the Cleveland Conservatory of Music, she was an accomplished pianist. She also authored numerous books. This 1920 photograph of Anice and Bert was taken at the lily pond at Sunnybank. (Courtesy Wayne Township Historical Commission.)

Milton Holbrook Sandford was a successful Massachusetts textile businessman and probably one of the wealthiest men in New England by 1870. Looking for a parcel of land on which to enjoy his horse-racing hobby, he purchased two adjacent tracts of land in Lower Preakness on the corner of Valley Road and Preakness Avenue in 1871. His favorite colt was named Preakness, pronounced "Prake-ness." In 1871, he won three of the seven races he entered. The Maryland Jockey Club used his name as the first winner of the new race for three-year-olds instituted in 1872. The Preakness is the second race in the famed American Triple Crown races.

In 1931, a radio-transmitting station was built and put into operation, located between the Newark-Pompton Turnpike and the Pompton River. A large antenna, a 50-kilowatt transmitter, and a tuning house were constructed. Owned and operated by the Columbia Broadcasting Company, the station used the call letters WABC. AM signal operations were discontinued in 1941, but the Voice of America, call letters WOOW, broadcasted Radio Free Europe to countries around the world and behind the iron curtain after World War II from the station using a short-wave transmitter. (Courtesy Wayne Township Historical Commission.)

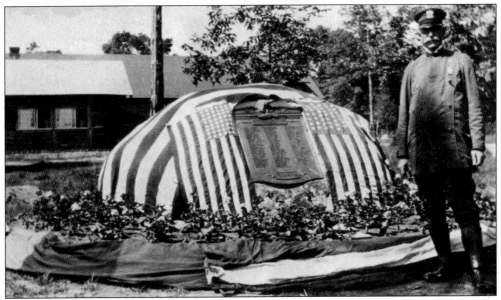

Police Chief Charles McGee is photographed next to the large stone, which was unearthed following excavation at the site of the Mountain View Club. The bronze plaque was added to honor Wayne veterans of World War I. (Courtesy Wayne Township Historical Commission.)

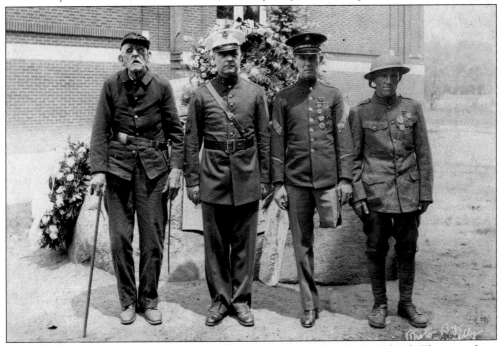

In 1931, this group of veterans stands in front of the Mountain View School. They are, from left to right, Cornelius Ryerson, Civil War veteran; John C. Bank, World War I veteran wearing the uniform of the Anthony Wayne Legion Post Drum and Bugle Corps; Harry Ryerson, World War I Marine who lost his leg in Europe; and Frank Rhinesmith, World War I veteran and vice commander of the Anthony Wayne Legion Post. (Courtesy Wayne Township Historical Commission.)

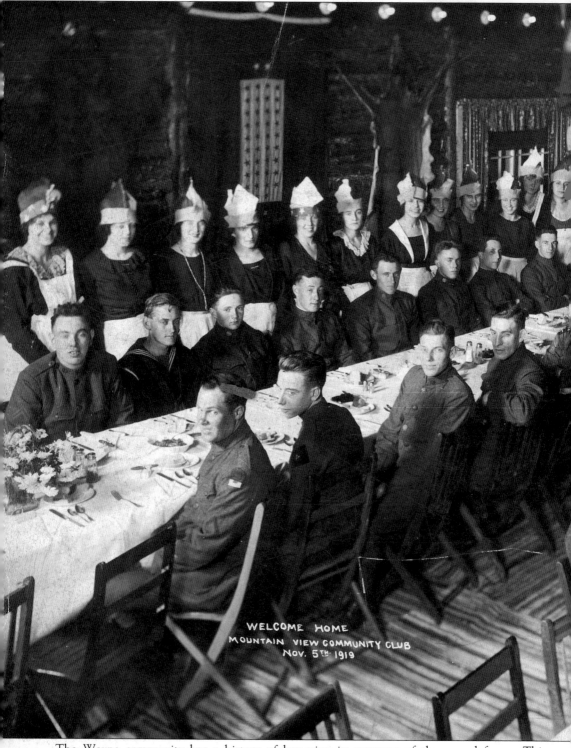

WELCOME HOME
MOUNTAIN VIEW COMMUNITY CLUB
NOV. 5TH 1919

The Wayne community has a history of honoring its veterans of the armed forces. This welcome home dinner was provided at the log cabin Community Club in Mountain View in

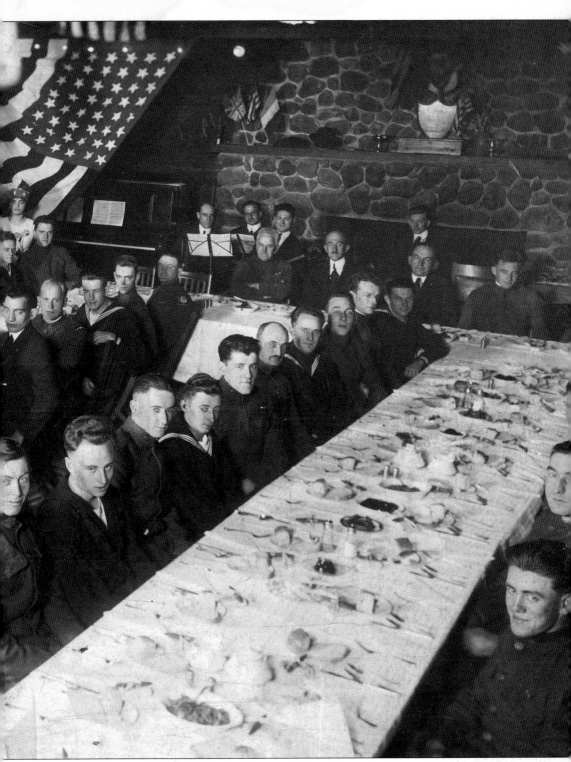

1919 following the end of World War I. (Courtesy Wayne Township Historical Commission.)

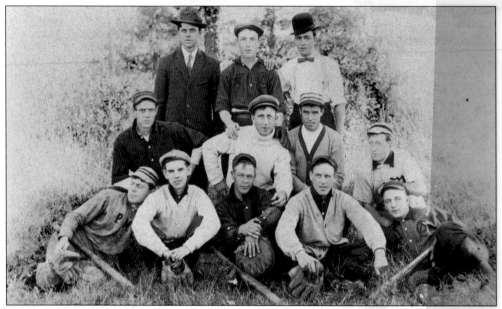

The Mountain View baseball team played on a field bordered by Route 23 in the west, Sherman Street in the east, Mountain View Boulevard in the north, and Greenwood Avenue in the south. The team is pictured in 1905 following a string of victories. (Courtesy Wayne Township Historical Commission.)

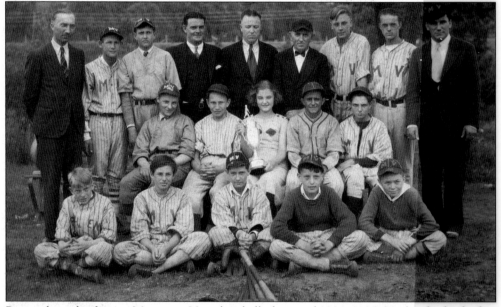

Pictured are the famous Mountain View baseball players of 1934–1935. Under the leadership of Coach Van Dyken, the team was victorious in the league championship. In 1935, they were named the number one team in Passaic County. In the sixth game of 1936, the team lost by a score of 1-0. Feeling cheated by what they felt was an umpire's bad call, the team rallied with unbelievable scores in their next games: 30-0, 18-0, 15-0, and 16-1. The team was mentioned in the nationally syndicated newspaper column called "Ripley's Believe It or Not." (Courtesy Wayne Township Historical Commission.)

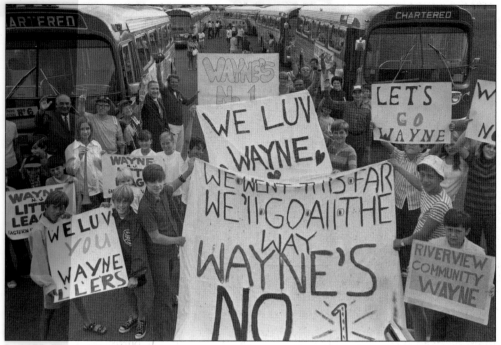

In 1970, Wayne's baseball prowess again gained national recognition, as the team from Wayne won the Little League World Championship. The chartered buses were ready to leave for the final three game elimination tournament in Williamsport, Pennsylvania. Community support for the team was unprecedented. The team was treated to a state police escort as it entered Wayne after the victory. Billboards, retail signs, and homemade posters throughout the community were decorated with congratulations for the boys. (Courtesy Wayne Township Historical Commission.)

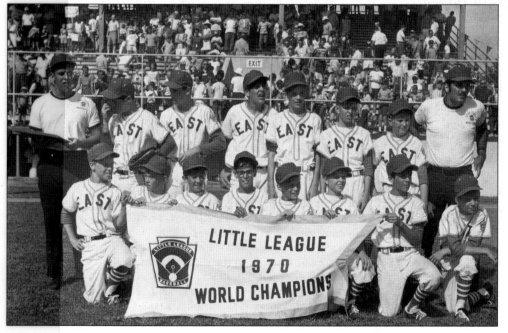

SELECTED BIBLIOGRAPHY

This volume serves as an introduction to 300 years of Wayne Township history. The author recommends the following books and publications for further study.

Bailey, Rosalie Fellows. *Pre-Revolutionary Dutch Houses and Families*. New York: Dover Publications, 1968.

Bayley, William S. *Iron Mines and Mining in New Jersey*. Vol. VII, Final Report Series of the State Geologist. Trenton: New Jersey Geological Survey, 1910.

Berce, William. *Under the Sign of the Eagle*. Wayne: Louis J. Vorgetts, 1965.

Boyd, Thomas. *Mad Anthony Wayne*. New York: Charles Scribner & Sons, 1929.

Brubaker, Robert M., Anne Brubaker Burns and Gratia Mahony. *"A Wondrously Beautiful Valley."* Wayne: Wayne Township Bicentennial Committee, 1976.

Goller, Robert R. *The Morris Canal, Across New Jersey by Water and Rail*. Charleston, South Carolina: Arcadia Publishing, 1999.

Jackson, Charles S. *The Singack and Mead's Basin Brickyards in Wayne Township*. Wayne: Wayne Township Historical Commission, 1978.

———. *The Van Riper-Hopper House*. Wayne: Wayne Township Historical Commission, 1973.

Labaw, George W. *Preakness and the Preakness Reformed Church: A History, 1695–1902*. New York: Board of Publication of the Reformed Church in America, 1902.

Lenik, Edward J. *The Archaeology of Wayne*. Wayne: Wayne Township Historical Commission, 1985.

———. *Indians in the Ramapos, Survival, Persistence and Presence*. North Jersey Highlands Historical Society, 1999.

———. *Iron Mine Trails*. New York: New York–New Jersey Trail Conference, 1996.

Letters of Lafayette to Washington, 1777–1799. Louis Gottschalk, ed. New York: Helen Fahnestock Hubbard, 1944.

Litvag, Irving. *The Master of Sunnybank, A Biography of Albert Payson Terhune*. New York Harper & Row, Publishers, 1977.

McCormick, Richard P. *New Jersey from Colony to State*. Newark: New Jersey Historical Society, 1981.

Powell, Richard. *The Pioneers Who Stayed at Home, The 100th Anniversary of the Sheffield Farms Company, Inc*. New York: Sheffield Farms Company, 1941.

Veit, Richard, F. *The Old Canals of New Jersey*. Little Falls: New Jersey Geographical Press, 1963.

Washington and His Generals of the American Revolution. Vols. 1 and 2. Philadelphia: Porter & Coates, 1885.

Whitehead, John. *The Passaic Valley in Three Centuries*. New York: New Jersey Genealogical Company, 1901.